PALESTINE

Donated

In Memory of

Alice C. Bell

By Her

Family and Friends

© 1987 GAYLORD

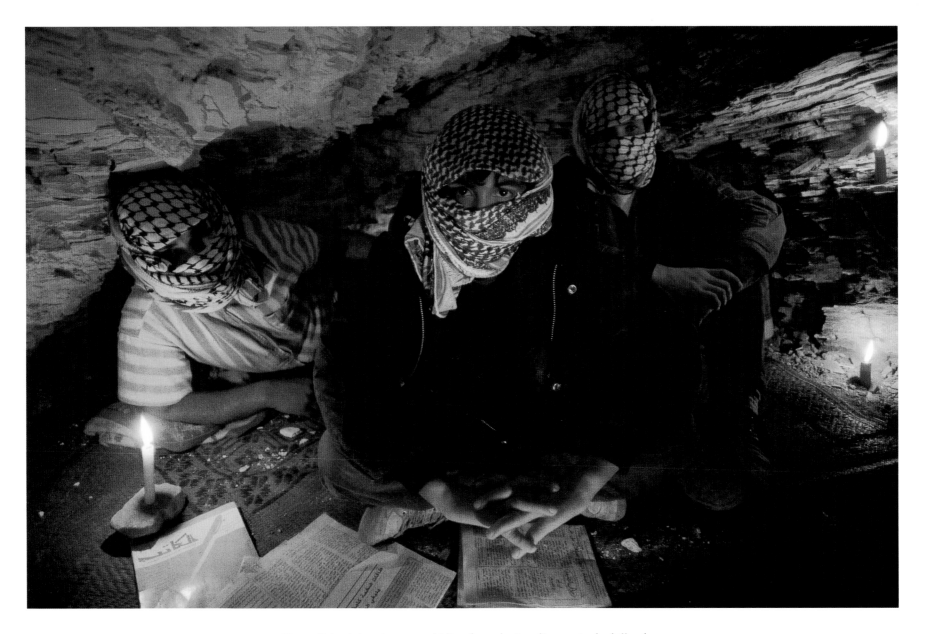

Young Palestinians in a cave, hiding from the Israeli army in the hills of the West Bank.

PALESTINE

A PHOTOGRAPHIC JOURNEY

George Baramki Azar

Introduction by Ann Mosely Lesch

UNIVERSITY OF CALIFORNIA PRESS

Berkeley Los Angeles Oxford

An earlier version of the Introduction by Ann Mosely Lesch was published in *Field Staff Reports,* no. 1 (1988–89), a publication of UFSI (Universities Field Staff International). Professor Lesch was a UFSI Associate in the Middle East from 1984 to 1987.

University of California Press
Berkeley and Los Angeles, California

University of California Press, Ltd.
Oxford, England

Library of Congress Cataloging-in-Publication Data
Azar, George Baramki.
 Palestine : a photographic journey / George Baramki Azar ; introduction by Ann M. Lesch.
 p. cm.
 ISBN 0-520-07384-3 (alk. paper).—ISBN 0-520-07544-7 (pbk. : alk. paper)
 1. Intifada, 1987—Pictorial works. I. Title.
DS110.W47A98 1991
956.95'3—dc20 90-24310

Grateful acknowledgment is made to Fouzi al-Asmar, Mahmoud Darwish, and Fadwa Tuqan, whose poems are reprinted in this volume, as well as to the publishers of the collections in which some of the poems first appeared: KNOW Books, New York; Free Palestine Press, Washington, D.C.; Three Continents Press, Washington, D.C.; Penguin Books, New York; and Zed Books, London.

Printed in Singapore
9 8 7 6 5 4 3 2 1

The paper used in this publication meets the minimum requirements of American National Standard for Information Sciences—Permanence of Paper for Printed Library Materials, ANSI Z39.48-1984. ∞

For my parents, George and Gladys,
my sister, Madelynn, my brothers, Michael
and Habib, and my wife, Randa

*We take this opportunity to extend warm
greetings to all others who fight for their
liberation and their human rights, including the
peoples of Palestine and Western Sahara. We
commend their struggles to you, convinced that
. . . freedom is indivisible, convinced that the
denial of the rights of one diminishes the freedom
of others.*

*Nelson Mandela,
deputy president of the
African National Congress, addressing the
United Nations General Assembly,
June 22, 1990*

Territories occupied by Israel since June 1967.

CONTENTS

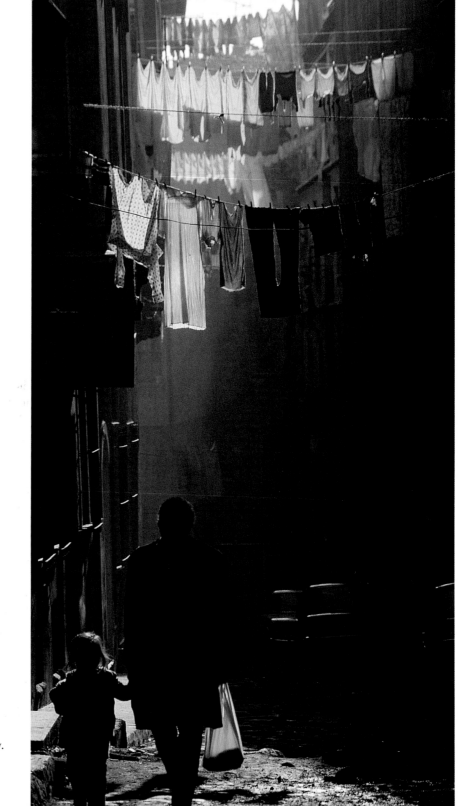

1. Sundown in Istanbul, Turkey.

PREFACE

My grandfather "Jiddo" Halim often spoke of a place where by custom a hungry traveler could pick a ripe fruit from an orchard, where snowy mountaintops overlooked the Mediterranean, and where villages with red-tiled roofs nestled in forests of cedar and pine. He called that country *biladi,* "my homeland."

On Sundays Jiddo's redbrick row house in South Philadelphia was crowded with visitors playing backgammon, cooking, and talking. The parlor was filled with stories. My aunts and uncles sat in heavy overstuffed armchairs. I sometimes sat on the floor, playing with my cousins and listening to my grandfather weave tales of cities built of gold-colored stone: Beirut, Jerusalem, Damascus.

The Arab world came alive for me through these stories, which sounded more like myths or fairy tales than like real life. One of them told of a potter in a tiny shop in the Damascus souk, or marketplace, whose water jugs, when filled from the bottom and turned upside down, would never spill a drop. Jiddo claimed to have seen an entire

Qur'an engraved in Arabic on a grain of rice. And he loved to tell how once as a young man walking the dirt road from his village to the Lebanese port city of Tripoli, he chased away five bandits with a tree branch.

Jiddo lived to be over a hundred years old. In his room he kept a heavy black iron safe that held a land deed from the old country. On top of the safe a white candle burned before an icon framed in wood. The icon depicted Elijah as an old man with a white beard swept by the wind as he flew to heaven in a chariot with flaming wheels.

I often studied this icon and others, painted early in the century by a relative, Michael Abbud, that hung on the walls of the tiny Syrian Orthodox church in my neighborhood. I searched the painted landscapes for clues that would tell me how the world my grandfather described really looked—the hills, streams, trees, and animals. The faces in these biblical scenes and portraits were long and dark, with almond-shaped eyes. They looked like my relatives' faces and those of

the other Lebanese and Syrians in the immigrant neighborhood where I grew up. I was drawn to these icons less for religious reasons than for what they told me of the Arab world, which otherwise remained a mystery. At that time, we never heard about it in school or saw it in films or on television. From the icons and the stories I heard at home, I understood a secret world and carried it close to my heart.

For a few days in 1967 during the Six Day War and later, in 1975, during the Lebanese civil war, Jiddo's world came alive through images on television. But news footage of the fighting showed an Arab world profoundly different from the one I knew—I could not reconcile Jiddo's world with one of Phantom jets, tank battles, or masked gunmen. I watched television with my family and saw bodies blackened by napalm, scattered like lumps of charcoal in the sand. I saw young men who had been shot through the head at checkpoints being dragged through the streets of Beirut behind speeding jeeps and BMWs. When I scanned the weekly news magazines, eager to learn more, I

found they offered little information about events in the Arab world and said almost nothing about the lives of the Arab people.

After I graduated from the University of California, Berkeley, in 1981, I spent the summer living in a small apartment above Telegraph Avenue. I was preparing to begin graduate school in international relations the following year. In July the Israeli air force, using American warplanes, bombed a neighborhood in Beirut called Fakhani, loosing stacks of seven-hundred-pound bombs on densely packed apartment buildings. Four hundred civilians were killed by the explosions or crushed by falling buildings. I read about the bombing in the newspaper, clipped the short article, and taped it to the refrigerator door so my friends could see it.

Each time I looked at this article I was overwhelmed. I could imagine how many news articles would have followed the death of four hundred Jewish civilians in an Arab attack; yet in 1981 the killing of four hundred Arab civilians by Israel was scarcely noticed. Even those who regularly spoke out in defense of human rights in Nicaragua, El Salvador, and South Africa were silent when it came to Lebanon and Palestine.

In the weeks after the bombing I grew increasingly troubled by my distance, as a student, from the real world. Like other students, I read books, sat in university lecture halls listening to professors, and had heated discussions around café tables cluttered with cups and newspapers. I wondered how our student discussions would change if we could hear the cries of men and women trapped under the rubble of a collapsed building.

By the end of the summer I had decided to see firsthand the world I had only read about. I left in September with my college roommate, Michael Nelson. We bought the least expensive tickets to Europe, flying to Brussels by way of Iceland, then riding buses and hitchhiking to Paris. From there we made our way across Europe to Istanbul, sleeping in youth hostels and in the stairwells of unlocked buildings. From Istanbul we traveled across Turkey and down the Syrian coast, entering Lebanon on Thanksgiving Day. We each had seventy-five dollars left.

In Beirut I began working as a news photographer, covering the Lebanese war as a stringer for the Associated Press and United Press International. I walked the streets looking for pictures, following the sound of gunfire.

Along the Green Line, the demarcation line running through the city center, I found block after block of Ottoman homes built of cut stone with red-tiled roofs, raked by machine-gun bullets and gutted by fire. Walls dangled in the air from twisted iron rods. Furniture, pots and pans, televisions, and toys spilled into the street from houses cleaved in two by explosives. Family pictures and airmail letters lay half-burned among the rubble. I could hear machine-gun fire and the reverberation of exploding shells.

Teenage militiamen with rocket-propelled grenades and machine guns were accomplishing the physical destruction of the country. They carried their weapons the way Philadelphia schoolboys carried footballs, with a certain confidence and grace. I carried a camera, but otherwise I looked a lot like them. From the beginning I was at ease with them and they with me. I felt both fascinated and dumbstruck at the everyday horror of their lives. I wanted to photograph these young men and to tell their story.

They took me into their world. I photographed them smiling, seated on their balconies with their families. I saw them wash their dogs and play cards in their spare moments. I photographed them sitting in their snipers' nests watching for pedestrians on the streets below. They waited patiently, smoking cigarettes and listening to Tom Jones on a battered tape player. I saw them leave innocent civilians lying in pools of blood. I went to their funerals.

From 1981 to 1987 I chronicled the Israeli invasion of Lebanon, the destruction of the U.S. Marine compound, the civil insurrection in West Beirut, the vicious interfactional war among the Palestinians in North Lebanon, and the Iran-Iraq war. I saw cars bombed and gun battles so numerous I can no longer remember them all. The political slogans I had once used with ease began to ring hollow. I saw so many deaths that my memory of them became a blur. By the time I left Lebanon there was no more room in the graveyards.

Living in Beirut, covering the war for *Newsweek*, I had no plans to go to Palestine. Then in June 1982, during the early days of the Israeli invasion of Lebanon, I was trapped under intense bombardment, abandoned by my driver in a small Lebanese coastal town called Jiya. After two days only a dozen refugees and a small squad of DFLP (Democratic Front for the Liberation of Palestine) guerrillas remained. The Israeli army entered the town and rolled through it after a brief intense firefight. Jiya was left in ruins. I was taken by the Israeli army and marched with them to the outskirts of Damour. Because I was a news photographer and U.S. citizen, I was not blindfolded, handcuffed, and beaten like the other Arab men I saw. I was held with a group of paratroopers in a large villa overlooking the ocean, the home of the former Lebanese president Camille Chamoun.

I was kept there for three days as artillery batteries fired endless rounds of high explosives into Damour. During the day the soldiers were tense,

awaiting the order to invade the town, expecting hand-to-hand combat. (They had heard tales of soldiers killed by fourteen-year-old Palestinians—a group called *ashbāl*, "tiger cubs"—who could somersault backward and fire rocket-propelled grenades.) At night one of the soldiers would bring out a guitar, and they would sing John Lennon songs. On the third day I awoke at midnight during a rocket attack. A group of Lebanese or Palestinian resistance fighters, hidden somewhere in the hills, was firing down on us—fighters I had been with just a few days before. The rockets missed by about a hundred yards and landed in the sea. After three days I was taken to the local Israeli command center, where I was interrogated, my cameras and pockets emptied, and my film destroyed. At the insistence of another photographer, Shlomo Arad, serving in the IDF (Israel Defense Forces), I was put on a military helicopter and flown out of the war zone.

This was how I first saw Palestine—from the sky, peering from the window of an Israeli military helicopter. I felt, in a strange way, like Elijah aloft in his chariot among the clouds above the Holy Land. Looking down, I could see funnel clouds of black smoke billowing from a dozen different points in the Lebanese countryside. Houses lay smashed by artillery fire. Burned-out cars and taxis, strafed by fighter-bombers, were strewn upside down or lying in bomb craters along the coast highway. Lebanon burned below. Columns of tanks snaked northward from Israel, laying waste the land.

The helicopter flew southward along the Mediterranean coast. When we crossed the Lebanese border into Israel, we seemed to enter another world, a continent away. Gone were the stone houses, green countryside, and farming villages. Rows of suburban ranch houses suddenly appeared. Small cars rolled down freshly paved black asphalt streets and stopped at traffic lights. I could see people clipping hedges, sunbathing, and watering lawns while a few miles away their dive-bombers pounded Lebanese cities to dust.

At the *Newsweek* office in Jerusalem I handed over two rolls of color film I had taken of the Israeli assault on Jiya and had hidden in my underwear: photographs of terrified Palestinian refugees trapped in a building being shelled and of Israeli battle tanks leveling Lebanese houses at point-blank range. When the magazine appeared the following week, it carried two of my photographs, one of two Lebanese militiamen firing a machine gun at Israeli jets, another of a PLO guerrilla walking past a destroyed building in Beirut. I never saw the photographs of the Israeli assault on Jiya again. The magazine claims they were lost.

After delivering my film to the magazine, I was free to go. Before returning to Beirut, I traveled to the occupied territories. The fighting was raging in Lebanon, but in the territories, despite the desperation of the Palestinian resistance, I saw no Palestinian flag—the most basic symbol of national unity and assertion. No demonstrators took to the streets. No one attempted to block the roads from the territories to the war front. At a time of profound national crisis, the people of the West Bank and Gaza were paralyzed by an iron-fisted military occupation and resigned to another in a long history of defeats.

When the *intifada,* or Palestinian uprising, erupted in the winter of 1987, I was living in the United States, taking photographs for the *Philadelphia Inquirer.* I tried my best to avert my eyes from the images on the evening television news of muscular Israeli soldiers pinning Palestinian men and women to the ground and methodically smashing their bones with clubs and iron bars.

I had left the horror of Beirut, Damour, and Tripoli behind and resisted the thought of going back to the Middle East. But in early January 1988 news reports night after night showed the people of the refugee camps, the villages, and the towns of Palestine taking to the streets. Protected by nothing save the cloth of their red-and-black kaffiyehs, armed with stones, they sought out and confronted an army of vastly superior power. They were utterly alone. I kept expecting the rebellion to falter, but it continued. After watching the struggle for several weeks, I went back to Palestine and began taking these pictures.

The territories had changed, hardly resembling the place I had photographed during the Israeli invasion in 1982. It was a time of hope and daring. The pealing church bells in Bethlehem, the cries from the tin rooftops of Gaza, and the echoes in the alleyways of Nablus were the sounds of hope. The fear and despair I had seen in 1982 were replaced by a sense of empowerment, especially among Palestinian women and young people. I felt the strength of the intifada as the collective will of a people no longer willing to be silenced—not by beatings, tear gas, or guns.

It has not been easy for Americans to perceive this will to endure a brutal occupation and emerge as an independent nation. The cries of the Palestinians are not heard here. Part of the reason is the clamp Israel placed around the West Bank and Gaza after the first few months of the revolt to choke off news photographs and video footage. But more significant is the dehumanization of Arabic-speaking people in the American mind.

There is an appropriate Buddhist metaphor: a person observing a rock garden often sees the rocks and notes their sizes and shapes but may never notice their shadows, which are equally part of the visual landscape. The shadows do not exist to whoever does not notice them. It is as though

they were invisible. Many Americans think about the crisis in the Middle East only when events there affect Israelis or Americans. Like shadows, the Arabs—Lebanese, Palestinians, Syrians, Iraqis—do not exist except when they threaten Jewish lives or American financial interests. For Americans the Arab world is invisible, or at best a shadow reality, dark, threatening, and unknown.

I took photographs of the shadow.

This is my notebook, recorded on color film. The words that accompany the photographs are translations of Arabic poetry, eyewitness testimonies, open letters, news clippings, and oral histories. Many are the words of people I met on my journey—words from the "other" people of the Holy Land, native Palestinians, out of the shadow for once, speaking for themselves.

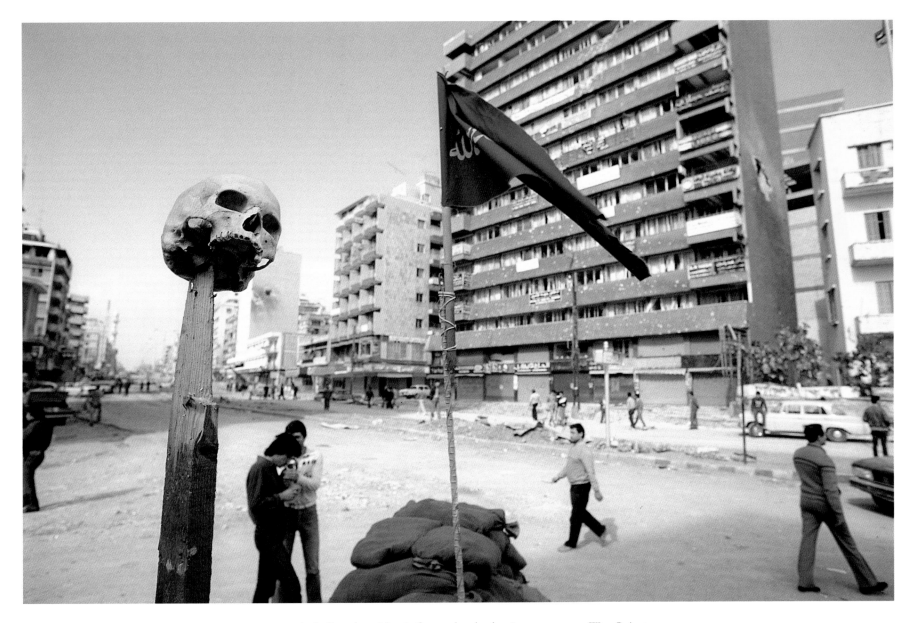

2. A skull and an Islamic flag at the checkpoint entrance to West Beirut
between the city's eastern and western sectors.

3. Israeli air strike on antiaircraft batteries above Ein al-Helwe refugee camp.

4. Civilians packed in a bomb shelter while artillery falls.

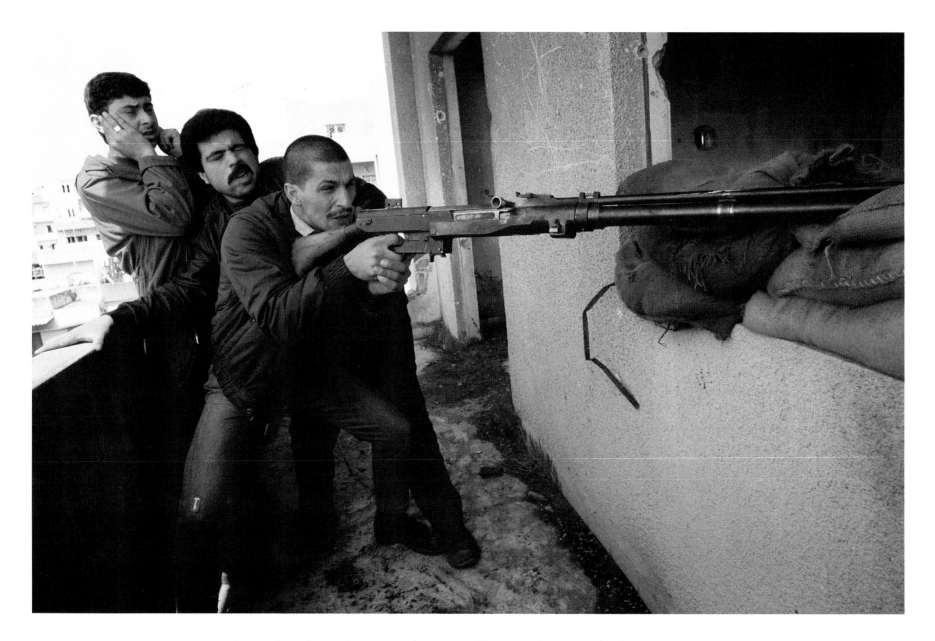

5. Snipers from the Amal movement fire a 14.5-caliber antitank gun at pedestrians in East Beirut. They fire through the house, keeping as many walls as possible between them and the enemy. Their nest is on the sixth floor of an abandoned building straddling the Green Line, in the southern suburbs of West Beirut.

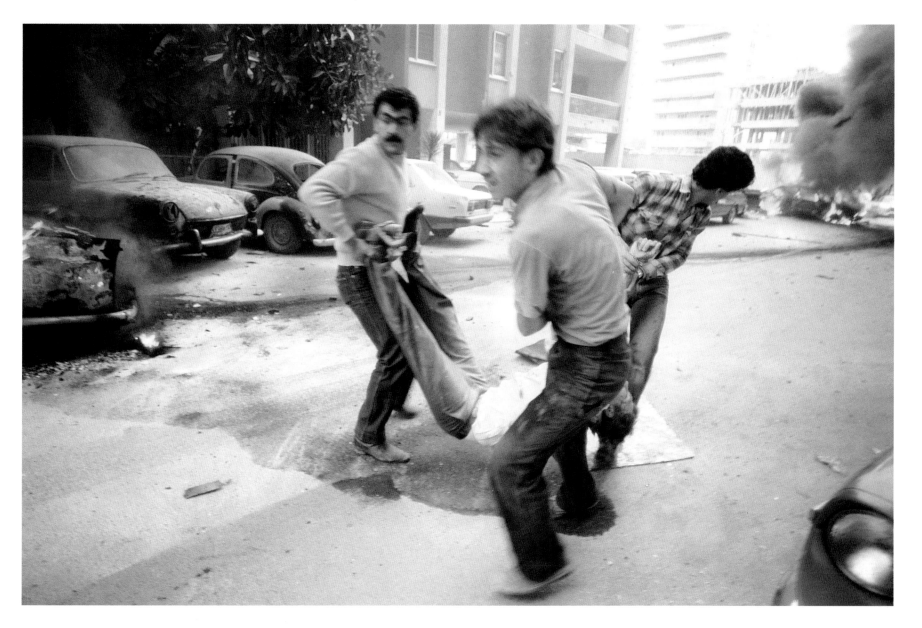

6. A wounded man is dragged to an ambulance during the bombardment of Roche, a seaside neighborhood in West Beirut.

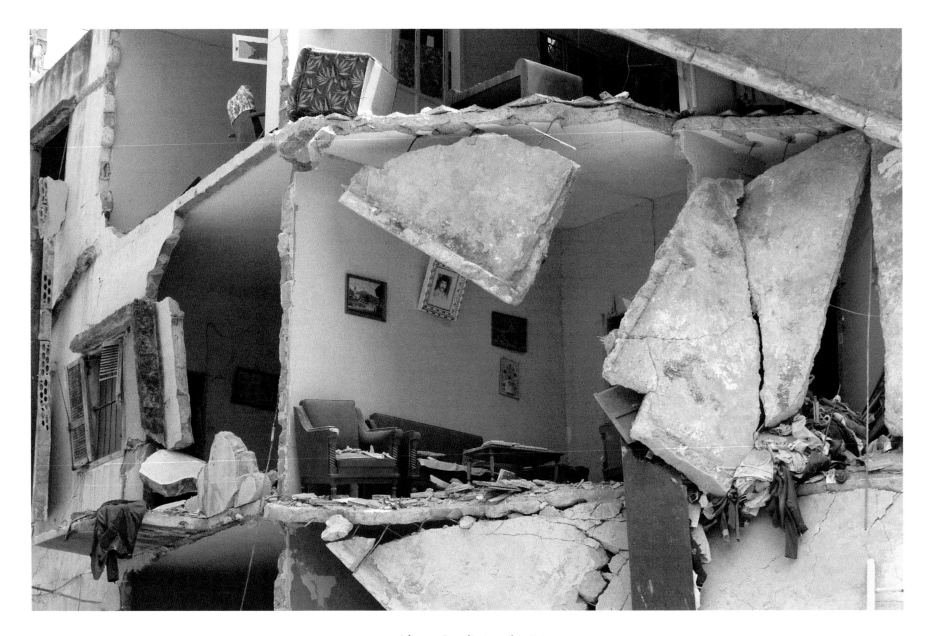

7. After an Israeli air strike, Beirut.

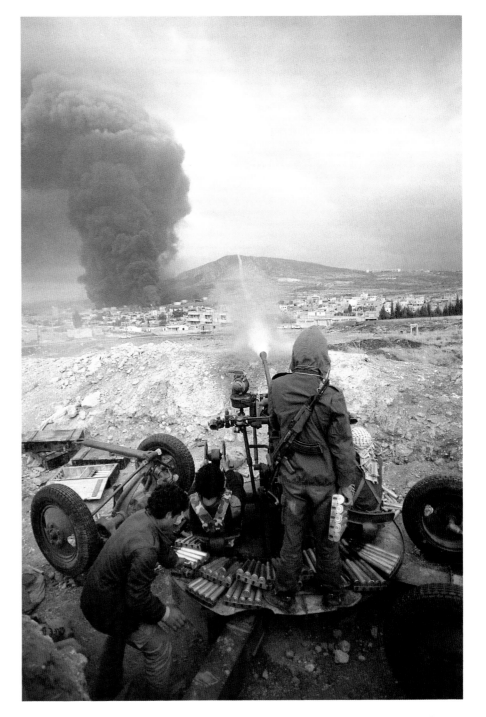

8. Palestinian guerrillas counterattack the Baddawi refugee camp during the war of the northern camps, 1983.

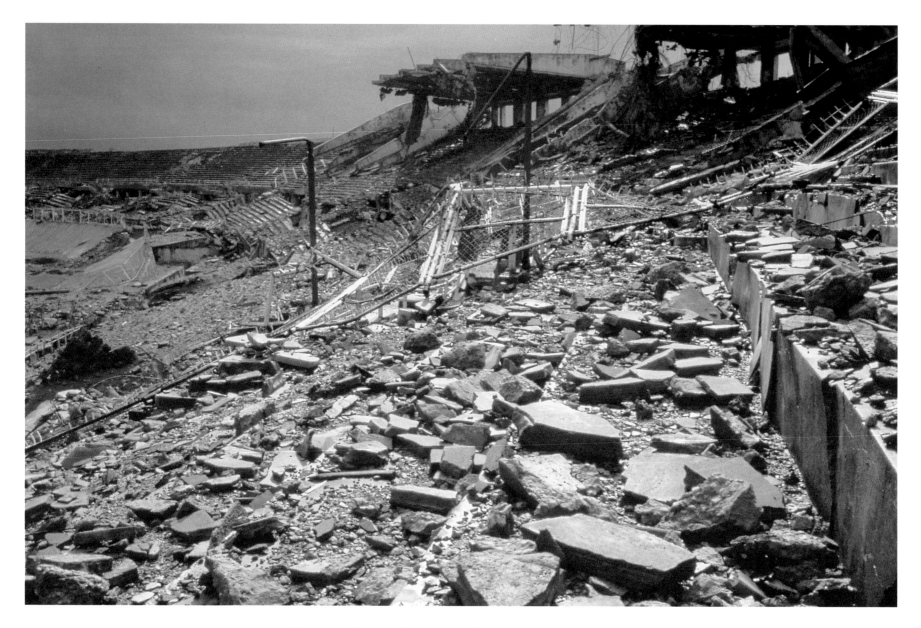

9. Lebanon's national stadium smashed by Israeli air strikes during the 1982
invasion of Lebanon.

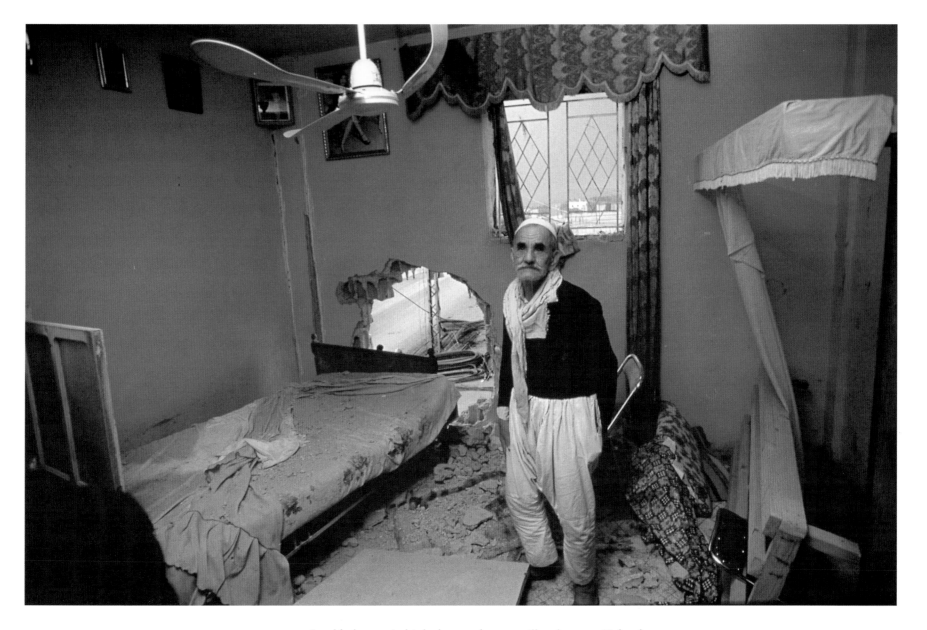

10. An elderly man in his bedroom after an artillery barrage, Nahr al
Barid refugee camp.

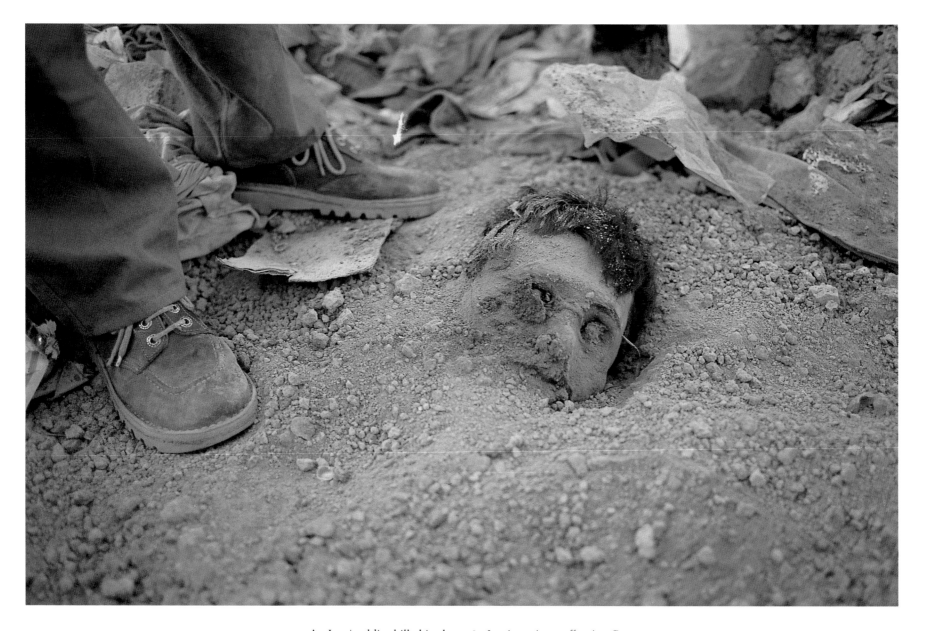

11. An Iraqi soldier killed in the 1987 Iranian winter offensive, Basra.

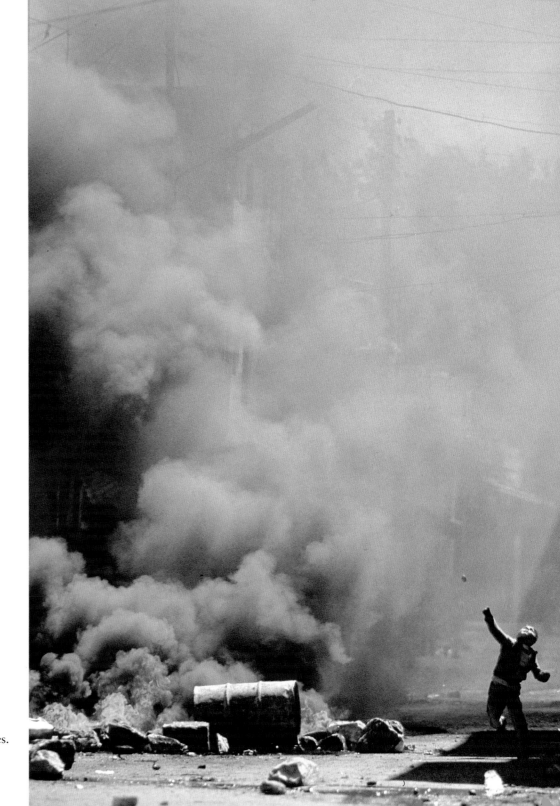

12. The war of the stones.

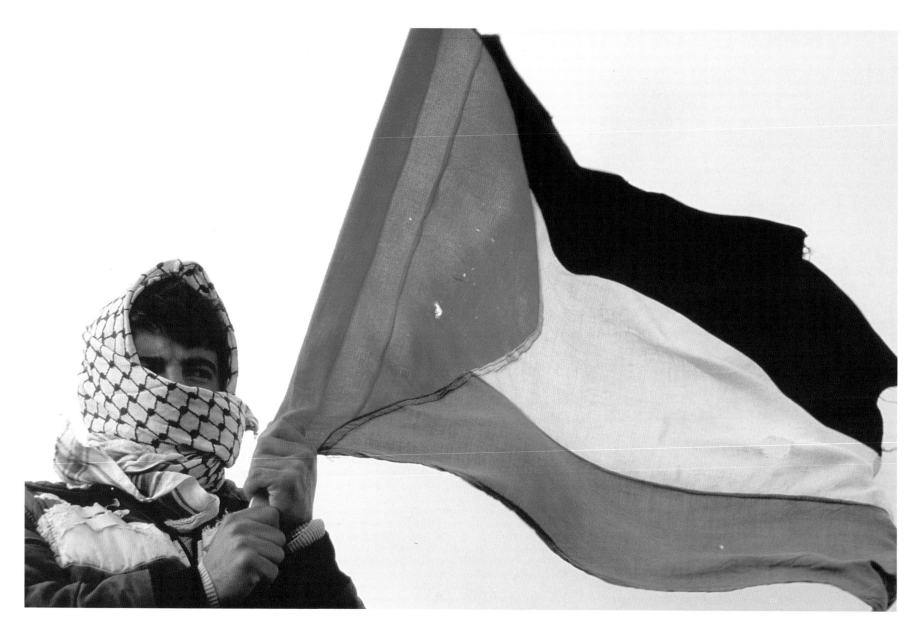

13. The flag of Palestine, Mazraʿa al-Sharqiyya.

INTRODUCTION

Ann Mosely Lesch

On December 8, 1987, the narrow road from Israel to the Gaza Strip was congested with cars and vans. They were filled with weary Palestinian men returning from a long day of work in Israel on construction sites, agricultural projects, and factories. Many had left Gaza at four in the morning, and all were anxious to pass the military checkpoint on the border in order to get home.

Suddenly, a large military tank transport ploughed into the line of vehicles, crushing one of the vans. Four workers died instantly and seven were seriously injured. The accident climaxed a period of mounting tension in the Gaza Strip. The day before, an Israeli had been stabbed to death on the main street of Gaza City. Some said he was a merchant from Tel Aviv; others claimed that he was a settler. A rumor spread swiftly through the crowded alleys of the refugee camps that the military truck had hit the Arab cars deliberately, in retaliation for the Israeli's death. It was more likely that the truck's brakes had failed, but the rumor quickly gained credibility.

Three of the four Palestinians who died came from Jabalya town, a pre-1948 village which has been nearly absorbed by the adjacent refugee camp. Their funeral that night turned into a mass demonstration. Thousands poured into the streets to express their anger and grief. Demonstrations continued the next day in Jabalya camp and town. When the Israeli army tried to contain them with tear gas and live ammunition, many people were injured and the soldiers killed a twenty-year-old youth. He became the first "martyr" from the demonstrations that marked the *intifada*, the uprising of Palestinians against twenty-one years of Israeli rule. The deaths in Gaza triggered sympathy protests on the West Bank. On December 10, soldiers shot to death a youth in Balata camp, a sprawling refugee zone next to Nablus. And the streets of other camps, towns, and villages filled with protests.

The "shaking off" (as *intifada* translates literally from Arabic) began through those spontaneous rejections of Israeli force and control. Few Palestinians would have estimated at the time that the protests would be sustained for years and that they would be transformed into a complex political movement whose aims grew from tactical demands related to the conditions of occupation to the strategic demand for independent statehood. Few would also have estimated that Israel would expand its military presence tenfold in the occupied territories, kill more than eight hundred Palestinians, and arrest thousands without breaking the back of the intifada.

For many observers it remains puzzling why the particular incident of the truck crashing into the van should have served as the catalyst for the intifada. Many similar incidents had occurred in the past, and the occupied territories had witnessed waves of protest over the past twenty years. Nevertheless, none of the past protests grew to encompass so many sectors of the society or was sustained for so long.

BACKGROUND

The West Bank and the Gaza Strip are the rump territories of Palestine. Three-quarters of the land became Israel in 1948–49, but the West Bank was held by the Jordanian army and the Gaza Strip was controlled by Egypt. Jordan merged the West Bank into the Hashemite Kingdom, granting its residents Jordanian citizenship. In contrast, Egypt ruled Gaza as military-occupied territory pending the formation of a Palestinian state. The West Bank was populated largely by indigenous towns-people and villagers, with refugee camps clustered near the towns and also concentrated in the Jordan Valley. In the Gaza Strip the balance was quite different: local residents were outnumbered by refugees, who struggled to survive in huge encampments along the Mediterranean coast.

Israel captured both areas in the war of June 1967. By now, some 850,000 Palestinians live on the West Bank, nearly 110,000 more in Jerusalem, and 650,000 in the Gaza Strip. Israeli law has been applied to the Arab residents of Jerusalem, but the rest have remained for twenty-four years under direct military rule. According to international law, the occupier cannot change their legal status until a diplomatic resolution takes place.

For the first ten years under the Labor party's rule (1967–77), the Israeli government applied a carrot-and-stick policy. On the positive side, it claimed that the territories were being held as bargaining chips until the Arab states would negotiate peace. Moreover, the government tried to establish a relatively normal economic life for the residents, allowing the Palestinians to export their produce to Jordan and to work in Israel. Municipal council elections were held in 1972 and 1976 so that elected bodies could act as buffers between the residents and the Israeli military command.

On the negative side, economic life was restricted so that it would not compete with the Israeli economy. Palestinian produce was prohibited from entering Israel, for example, whereas Israeli goods could be sold freely in the occupied territories. The municipal councils were not allowed to develop into political bodies, and no regional authority was established to coordinate the councils. In addition to building a dozen Jewish residential quarters in East Jerusalem, the Israelis erected forty-one settlements for Jewish residents on the West Bank and in the Gaza Strip, in violation of international law and contravention of the asserted policy of holding the territories as bargaining chips. In fact, by the mid-1970s, Israeli officials heading the Labor party argued that the Jordan Valley, the settlement zone near Hebron and Bethlehem, Jerusalem, and the Gaza Strip would never be relinquished, even in return for peace. Moreover, the military forces clamped down hard on any protests. Striking lawyers and teachers in the initial year of occupation and municipal councillors protesting house demolitions and trade restrictions met with arrest and deportation. In the Gaza Strip, Palestinian guerrillas mounted a full-scale insurrection in the late 1960s, which required massive action by the Israeli army to crush. By 1978, more than 1,500 Palestinians had been forcibly expelled to Jordan or Lebanon. If residents staged demonstrations, curfews were imposed on the camps or towns.

The Palestinians themselves were confused in their political objectives and limited in their organizational skills. At first, they could not believe that the occupation would continue long. Israel's rule over Gaza had lasted only five months in 1956–57, and Palestinians assumed that the United Nations and the major powers would compel a similar evacuation this time. Nonetheless, the assumption that the political situation would return to the status quo ante was challenged by the burgeoning Palestinian guerrilla movement under the aegis of the Palestine Liberation Organization (PLO). Fedayeen established bases in Jordan from which to attack Israel and the West Bank, promoting the cause of Palestinian nationalism and calling for the replacement of Israel by a nonsectarian state.

Just as the guerrilla movement was capturing the imagination of young Palestinians, the PLO was defeated in a military showdown with the government of Jordan, which expelled its leaders in 1970–71. Despite the setback to the guerrillas, the PLO's diplomatic potential grew. Moreover, Palestinians from the West Bank played an important role in convincing PLO leaders to change their demand from the destruction of Israel to the establishment of a state for Palestinians alongside Israel. That strategic shift in position was signaled by resolutions of the Palestine National Council (PNC) in 1974 and 1977.

But the PLO's diplomacy gave mixed signals since the Palestinians themselves remained divided in their aims. Some continued to seek the destruction of Israel and the return of Palestinian refugees to their original homes. Others accepted the idea of a limited two-state solution, even though that would secure the Palestinians only a quarter of their original land. Still others felt that a return to Jordan was the only practical route since the United States and Israel would not include the PLO in negotiations.

Soon after the Likud bloc came to power in Israel in 1977, the carrot side of Israeli policy disappeared. The government defined the West Bank and Gaza as liberated territory and deliberately placed Jewish settlements in the midst of Arab-

populated areas, tripling the numbers of Jewish colonists and making re-partition of the land virtually impossible. Long-range plans devised by the Jewish Agency called for an equal number of Jews and Arabs in the territories, thereby completing their de facto absorption into Israel. Prime Minister Menachem Begin's concept of autonomy for the Palestinians, articulated at the time of the Camp David accords, made clear that self-rule would not include control over vital water and land resources. His concept was fundamentally different from the American and Egyptian view that autonomy could lead to an independent state or at least to federation with Jordan. Moreover, in 1980–82, the Israeli military government clamped down on the municipal councils that had been elected in 1976, closing down virtually all of them. Israeli colonels ran the towns directly, and the facade of local rule disappeared.

The moves to constrict political life were accompanied by massive land confiscation and the establishment of Jewish settlements in the midst of Palestinian villages. Fields, orchards, and grazing areas were seized throughout the West Bank and a dense settlement zone was formed at the south end of the Gaza Strip. The permanency of Israel's presence was reinforced by the Likud's settlement drive. And the livelihood of the villages was directly undermined, forcing an increasing number of men and women to take menial jobs in Israel to survive.

Those moves peaked just as Israel invaded Lebanon in June 1982. That attack was designed in part to restructure the Lebanese political map but also to eliminate the military and political presence of the PLO on Lebanese soil. Defense Minister Ariel Sharon stated, moreover, that once the PLO's power was gone from Lebanon, the Palestinians on the West Bank and in Gaza would ac-

cept the status quo and make peace on Israel's terms. The consolidation of Israeli rule and the absorption of the territories would be complete.

The situation in the territories was grim during the ensuing years. The fractures within the PLO following the exodus of its leaders and fighters from Beirut were reflected among the residents of the West Bank and Gaza. Rival groups vied for influence, and the Islamic movement actively opposed all the secular nationalist trends. Tensions were reflected, for example, in the student council elections at the universities and in the formation of separate women's groups under the different political aegises.

Israeli policies also toughened when Labor's Yitzhak Rabin became minister of defense under the National Unity government formed in late 1984. In August 1985, Rabin announced the policy of the Iron Fist: if the Palestinians caused any trouble, the military would subdue them. Within a month, Rabin had deported a dozen political activists and placed sixty-two persons under administrative detention—in which no charges are brought against the detainees, who can remain in jail indefinitely without standing trial. Moreover, five Palestinians were killed by the military. Collective punishment was also resumed. The first house demolitions took place after a hiatus of several years. The tough measures, intended to intimidate the Palestinians into submission, instead served to increase their anger and despair.

CATALYZING EVENTS

The combined result of the weakening of the Palestinian movement outside the territories and the crackdown by the military government was that the Palestinians in the West Bank and Gaza began to realize that they must organize them-

selves more effectively to prevent their destruction as a community. They realized that they could not rely on negotiations originating from outside, since the PLO alone could not alter the diplomatic situation and the United States, particularly during the Reagan administration, could not be expected to undertake a serious diplomatic initiative in the Middle East. Already the United States had allowed the Hussein-Arafat initiative of 1985 to wither even though it offered the land-for-peace formula and the promise of Palestinian-Jordanian confederation that the United States ostensibly had sought. The realization that they could not count on outside support became particularly acute as the Iran-Iraq war raged nearby, sucking up Arab resources and diverting attention from the Palestinian plight.

On the one hand, that realization led to acute depression and fear that they would be absorbed into Israel as a permanent underclass. On the other hand, it impelled them to start providing their own organizational structure for a protracted struggle. Since political organizations were banned by Israel, their efforts focused on grass-roots charitable structures and cultural institutions.

The impetus for a strategy of self-reliance also derived from the Palestinians' observation of the Shia militants' effectiveness in Lebanon in 1983–85. The Israeli army, which had defeated the Arab military forces and which Syria had feared to confront in 1982, had retreated in the face of the suicidal car bombs of the Shia organizations. The villagers of south Lebanon had risen up against alien occupation and had compelled Israel to withdraw. That was the first time that Israel had left occupied territory not as a result of negotiation but as a result of guerrilla harassment and a loss of political will. The Palestinians on the West Bank and in

Gaza viewed the withdrawal as a possible precedent. They knew that they could not use violence in the manner of the Lebanese, but they could use the example of popular mobilization as a moral force to shift the political advantage from Israel's side to their own.

During 1987, two key developments crystallized the views of the Palestinians and promoted organized action. The first was the Palestine National Council meeting in April, and the second was the Arab summit conference in November. The PNC played a crucial role in ending the most important cleavages within the PLO. The Popular Front and the Democratic Front resumed their seats on the executive committee, which they had vacated after the 1982 schism in the PLO. Moreover, a representative of the Communist party was added for the first time. The CP had been strong for decades on the West Bank and in Gaza but had been weak outside and was not represented in the PLO bodies. The PNC thus brought together the main organizations that made up the Palestinian movement under the continuing leadership of Yasir Arafat and Fatah. This occurred despite the strong opposition of Syrian President Hafiz al-Asad, who promoted a renegade faction of Fatah under Colonel Abu Musa.

The effect of the rapprochement among the key groups was already evident by June 1987. When I visited the West Bank that month, I found that the social and unionist organizations sponsored by the different movements were beginning to work together and that a common sense of purpose was beginning to emerge. The organizational basis for the intifada was, in fact, being established.

Moreover, the Islamic movement began to participate alongside the nationalist groups for the first time. Previously, Islamic-oriented Palestinians had been not only aloof from the nationalist current but overtly antagonistic to it. That antagonism had played to Israel's advantage. When a large crowd marched from a mosque in Gaza, for example, to attack the pro-PLO Red Crescent Society and to burn two restaurants that served liquor, the army did not intervene. Similarly, when Islamist students clashed with nationalist and leftist students on university campuses, Israel welcomed the diversion.

Nonetheless, some Islamist youths who had served time in jail came to view their goals as compatible with those of the national movement. They construed the primary enemy as Israel, not their fellow Palestinians. Organized as the Islamic Jihad group (but not linked to the organizations of the same name in Egypt and Lebanon), they began in summer 1987 to cooperate with Fatah in Gaza. Key leaders of Jihad had escaped from an Israeli prison in May and had hidden in the Strip. In August during the feast of Id al-Adha, which marks the end of the season of pilgrimage, they killed an Israeli military police commander driving his car in the center of Gaza in broad daylight. In October they engaged in shoot-outs with Israeli troops, sparking demonstrations at the Islamic University in Gaza. In November a prominent sheikh from the university was arrested and slated for deportation as a "spiritual leader" of Jihad. For the first time, an Islamic-oriented group took the lead in the struggle against Israeli rule. That helped to electrify the atmosphere.

The hang-glider attack from Lebanon on November 25, 1987, also served as a catalytic event. One of the Palestinian guerrillas managed to escape the Israeli net and enter a military base in north Galilee. When the guard at the gate ran away, the guerrilla entered and killed six people before he was overpowered. The sheer audacity of the raid—and the acute embarrassment it caused Israel—kindled the imagination of Palestinians in the territories.

Finally, the summit meeting of Arab states that convened in Amman in mid-November was a turning point for the Palestinians. The purpose of the meeting was to coordinate Arab responses to the Iran-Iraq war, which had dragged on since September 1980. Since summer 1987 the war had threatened to engulf the surrounding countries and suck in the superpowers, who mounted guard duty to protect shipping in the Persian Gulf. King Hussein viewed the escalating Iran-Iraq war as the first priority for the Arab world and as the vehicle to bring Egypt back into the Arab fold. Virtually all Arab countries had broken diplomatic relations with Egypt after its peace treaty with Israel in 1979. Although Jordan had resumed relations in 1984, no other country had followed suit. Now, Jordan argued that Egypt could provide strategic weight on the Iraq side of the Gulf war and could help to isolate Syria and Libya, the only Arab countries supporting Iran. Thus the November summit emphasized a common Arab plan to assist Iraq against Iran. It also permitted each Arab government to decide freely whether to reestablish relations with Egypt. By January 1988 Saudi Arabia and the rest of the Gulf states had returned their ambassadors to Cairo, and Egypt was advertising its ability to supply military advisers to the Gulf regimes.

From the perspective of the Palestinians, these developments were sobering. Arafat, treated with disdain by Hussein, had played only a minor role at the summit. Egypt had been welcomed back despite its diplomatic relations with Israel and the failure to reach a comprehensive peace accord involving the Palestinians. The Arab rulers met with their backs turned toward Palestine, facing the Persian Gulf. The Palestinians were shocked into

comprehending that the Israeli occupation had a low priority in Arab rulers' strategies.

In retrospect, one can see a crystallization of trends. Israeli programs to absorb the territories and quell the aspirations of the residents were peaking. With the deterioration in economic and political life, Palestinians felt they had reached a dead end: they were not living as free human beings, and they had no hope for the future. That sense of total blockage internally combined with the feeling that no help could be expected from outside. The PLO was too fragmented and distant, and the Arab states had lost interest. Europe and the Soviet Union lacked leverage, and the United States was too committed to Israel to comprehend the Palestinian situation, much less broker a satisfactory accord.

At the moment when all internal and external forces appeared to block the Palestinian path, the intifada erupted, led by youths born after the occupation began, who had lived face-to-face with the Israeli military all their lives. Their uprising broke the barrier of fear that had paralyzed the generation of their parents.

THE INTIFADA

Demonstrations began in the refugee camps, which had always been the key locus of protest. Densely packed with those dispossessed since 1948, the camps, with their poor living conditions, were an ideal breeding ground for the organized expression of discontent. From them the protests spread to the towns, where in the past the poor had often participated in demonstrations, as had middle-class merchants and professionals. In fact, professionals had been the organizers of many protests and had been disproportionately subject to detention and deportation.

Finally, the demonstrations extended to the villages. In Gaza, villages had merged over the years with the camps and towns. But on the West Bank the more than five hundred villages were scattered widely, some perched on mountaintops, others hidden in remote valleys on narrow back roads. The villagers were particularly motivated to join the intifada because of the expropriation of their land. No village had remained unaffected by the massive seizures that had taken place since 1979. Each had a tale of confrontation and loss involving settlers and soldiers.

I visited Sair, in a rocky defile east of Hebron, in June 1987 to see three houses that had just been demolished by soldiers. Men from the families had been involved in guerrilla operations against the army. The villagers said that when the army came late at night, without warning, to carry out the demolitions, Israeli settlers from Kiryat Arba joined them. The settlers performed a dance of joy in front of the houses while the families wailed and children and old people hugged bundles of clothing salvaged before the dynamite destroyed the solid stone buildings. The anger and disgust were palpable as they described the macabre midnight scene.

The involvement of villagers, who had remained largely outside political life in the late 1960s and early 1970s, was crucial to the intifada. It posed particular problems for the Israeli armed forces. Given the large number of villages and their relative inaccessibility, the army could control only about a hundred at any one time, a fifth of the total. Thus the majority of villages considered themselves "liberated." Moreover, when an incident occurred in one village, the army would rush there. Meanwhile, something would happen in another distant spot—and the troops would rush off in that direction. The army could be kept

off guard, continually running after the latest incident.

The military could control the refugee camps much more easily than the villages. Ever since the demonstrations of the mid-1970s, the camps had been barricaded by cement walls, with only one exit left open. Now, access has been further sealed by high concrete and wire-mesh walls, which ghettoize the residents. Moreover, the Gaza Strip as a whole can be closed off to the outside since only two roads lead into it. Barbed wire and army patrols, in place since 1949, separate the Strip from Israel. In contrast, the West Bank is difficult to seal off from Israel. Myriad small roads and even goat paths lead into it. A massive mobilization is required to establish roadblocks on every artery.

I observed those phenomena in late March 1988, when I visited the West Bank for a week. One day I drove north with a group of visiting academics to villages near Nablus. As we turned west from the main highway onto a narrow road, our path was blocked by boulders. Only a bicycle could weave between them. Youths from the next village had blocked the way so that army vehicles and settlers' cars could not pass. They said that the army used to enter the village with convoys of jeeps and buses. Greeted with a fusillade of stones, the soldiers would fire on the villagers and haul teenagers onto the buses for an extra beating. Settlers drove through the village late at night, honking car horns, shouting curses, and threatening to return to smash the windows of the houses and expel the people.

The villagers' stone barrier kept out—or at least slowed down—the intruder. Once their youthful outpost decided that our group had friendly intentions, they helped us remove enough boulders so that our bus could pass. Then they rolled the rocks back into place. As we drove

through the narrow village, we were greeted by the curious stares of women and girls from the windows and balconies, the bold V signs of youngsters on the streets, and the cautious glances of men clustered on the stoops and outside the coffee shop. Hand-painted Palestinian flags fluttered from the electricity wires, and graffiti were scrawled on the walls: Down with the Occupation and Palestine Lives. Behind their makeshift barricades, the villagers viewed themselves as a liberated island.

As we approached the next village, teenagers were busy removing rocks from the road. The word had already been conveyed that we were friendly, and so we rolled into Salfit's main square amid welcoming greetings. An Iowa-educated professor at Nablus's Najah University described some of the hardships the village was facing. With schools closed since February 2, the adults were trying to devise informal classes for children. Lessons were sporadic, however, and other social services were also limited. It was often difficult to reach the hospital in Nablus because of curfews and army roadblocks. The drastic drop in the number of men working inside Israel had affected incomes. But local agriculture had benefited, since many men were returning to tend the land. Even though Salfit had lost half its cultivated land to Ariel settlement (named after Ariel Sharon), small patches of vegetables and melons were planted among the remaining lemon and fig trees, so the residents could eat off their own land during the summer.

As young people clustered around us, they expressed little anger or animosity. Rather, they articulated a sense of pride in what they were accomplishing and a strong sense of determination. When asked by an American how he would react if an Israeli bus drove into Salfit, a teenager responded: that would depend on why they had come; if they came to understand our situation, as you have come, and to reach out for peace, then we would welcome them.

In the next village we found a strong feeling of solidarity with the other Palestinian villages and towns. In Bidya three houses had recently been demolished because their owners apparently were active in village protests against the mayor. He was viewed as a collaborator with the Israeli authorities, who allowed him to carry a gun and provided him with an armed escort. Despite the residents' anger at the house demolitions and their need to care for the affected families, the villagers had made a special effort that morning to collect fruit to send to Nablus. For more than two weeks the army had banned the entry of any food or gasoline into that city of nearly 100,000. (Later, as we entered, we saw bread and lemons dumped at the side of the road by soldiers manning the roadblock, and our bus was checked carefully to make sure we were not smuggling in any supplies.) Bidya villagers had filled a van with fruit and slipped it into the city through back roads. Despite their own suffering, they had the energy to help others in need.

The saga in Salfit had a bitter ending. Only an hour after we left the village, troops attacked it. Nearly one hundred soldiers fanned out across the fields and charged into it. Children on the rooftops alerted residents to the attack and greeted the soldiers with stones and iron bars. In the melee, soldiers swept through the alleys and raced onto the rooftops, injuring many residents and killing two youths. One of them, who had been standing amid a group of teenagers throwing rocks, was picked off by a sniper on a rooftop. His mother, seeing him fall, grabbed him in her arms and rushed him to a nearby olive grove, where he died.

She wanted to keep him away from the soldiers, who would have taken the body to a hospital for an autopsy and then would have returned it late at night, allowing only the immediate family to bury it. When the family keeps the body, the funeral becomes a large demonstration. The casket is draped with the Palestinian flag and nationalist chants drown out the funeral dirge.

My brief excursion into the Nablus area gave me a vivid impression of the resiliency of the villagers—their determination to create independent enclaves, to strive for self-sufficiency, and to link their struggle to the larger cause. Such an effort is much more difficult to sustain in the refugee camps, which lack internal economic resources and do not have their own wells or cisterns. Thus they can be isolated, their water supply and electricity cut off, and the ingathering of food blocked. Without kerosene for lamps and stoves, with no water or food, they can be starved into submission.

Such problems are particularly acute in a small camp like Jalazone, perched on a hillside north of Ramallah. It lies directly below the main highway. Soldiers standing on the road or on nearby hills can look down directly into the camp. Thus the army can enforce tight curfews for days on end. Although the United Nations Relief and Works Agency (UNRWA) is supposed to be allowed to bring in basic food supplies and collect garbage during curfews, the army sometimes blocks those services. The curfews cause immense suffering, compounded by the ability of snipers to pick off anyone who ventures outdoors, even for a breath of fresh air.

By contrast, in the huge camps of the Gaza Strip, the army has more difficulty controlling the population, even during curfews. When I visited the Strip in August 1988, I heard of mass actions

that had overwhelmed the soldiers on duty at the entrances. For example, in one camp a curfew had lasted for four days without a single break. No one was allowed outside. Tear gas grenades were lobbed into windows left unshuttered in the houses to provide ventilation. There was no way to get food. One afternoon, the word was whispered through the camp that all the women would walk out of their houses simultaneously at 5:30 P.M. and head to town with their shopping baskets. At precisely 5:30, all the gates opened and more than five thousand women and girls entered the alleys and streets. That steady stream of humanity shouted at the soldiers to shoot them. They were determined to get food for their families, they cried. Since they risked dying of starvation, the soldiers might as well kill them now. Faced by the onrush of black-clad fist-waving women, the soldiers stepped aside.

But the outcome was not always nonviolent. On May 30, in Jabalya camp, in the midst of a curfew, a soldier threw a tear-gas grenade through a window into a small room. A woman dashed into the courtyard, carrying her baby. The yard was also full of gas. Choking, she fled into the alley. But that was packed with soldiers. One aimed directly at her and shot seven rubber-coated bullets into her and the baby. Although the baby was rushed to Ashkelon hospital, the little girl lost her left eye. Three months later, I could see large patches of scar tissue on her right arm, left leg, and stomach. Her grandmother, still boiling with anger, screamed at us as we sat on mats playing with the child in her frilly white dress. The grandmother was furious at everyone from outside, who did nothing to stop the soldiers and could do nothing to restore the child's vision and beauty.

As we left the house, a shy young woman pulled me aside to tell me that many of the baby girls born that summer were named Intifada. Many of the boys were called Thā'ir, "revolutionary."

ORGANIZATION OF THE MOVEMENT

The intifada is different in significant ways from prior manifestations of protest. In the past, mayors and intellectuals led the movement; by now, many of them have been deported and their organizations disbanded. Since they tried to operate publicly, their names were known and their societies could be closed down by the Israeli government. The leaders of the intifada have deliberately sought to remain anonymous and to keep their organizational structure fluid. Proclamations are issued in the name of the Unified National Leadership of the Uprising, but individual names are unknown. The major groups that were reunited at the PNC in 1987 appear to be included in the leadership, notably Fatah, the Democratic Front, the Popular Front, and the Communist party. The leaders are apparently youthful and closely attuned to the needs and views of the community.

The overall leadership is linked to myriad neighborhood committees that deal with health, agricultural, educational, and women's issues. For example, in each section of a town, residents elect a committee to coordinate efforts and handle emergencies. Residents donate a small sum so that food can be stockpiled for emergencies. A team checks and cleans old wells and cisterns for use if Israel cuts the water lines. A census is taken of all the residents so that each person's skills are known, and each resident is assigned a role to play in case of emergency. Even the illiterate woman with several children, who has a weak sense of self-worth, is assigned a task—perhaps to bake bread for the neighbors or to watch a group of

children—if the district is besieged. She now feels pride in herself and in the role she would play to help the neighborhood. The neighborhood committee also supervises the planting of vegetable gardens, tended by young men and children. Some are located in vacant plots, others in backyards.

Health committees also play important roles. Doctors go to villages on an organized rotation to provide aid. Residents with cars are available to rush victims to hospital on a moment's notice. Paramedics are trained to treat the wounded. In Gaza, medical groups have organized seminars for women and young people in the camps. They are trained to cope with the effects of tear gas: pamphlets with diagrams show how a damp cloth wrapped around pieces of onion can be held against the mouth and nose and how gas canisters can be doused in a can of water and another of sand. Another instruction booklet shows how to make a stretcher from a door and how to strap a leg or arm in a splint. Doctors and UNRWA personnel told me that this grass-roots instruction has had a significant effect in raising morale as well as reducing the seriousness of injuries.

The communities have found it more difficult to organize alternative schooling. The universities were closed by the military government in January 1988 and schools on the West Bank were shut in early February. More than a month elapsed before the residents began to organize alternative schools out of concern that their children might lose a semester or more of instruction. The universities could only manage to arrange informal classes for the graduating seniors, but several neighborhood schools sprang up. Some mixed together children of different ages from the district; others tried to organize on the basis of grade levels or subjects. The "freedom schools" could teach according to their own curricula, free from Israel's control, but

they were risky ventures. The military threatened to arrest anyone participating in the schools, and it was difficult to bring together a group of youngsters without being detected. When the government reopened the schools in the summer, the alternative instruction folded. But the idea of developing a Palestinian curriculum and educational system has remained, and a quiet effort to reform schooling has developed among educators.

Communication on educational and political issues takes place partly by word of mouth, but it is organized and articulated especially by *bayanat*, two-page mimeographed sheets that appear at night around the West Bank and Gaza at intervals of a week to ten days. In the first eight months of the intifada, twenty-four bayanat were distributed, and they continued to be issued. The printing is rough. In the beginning, the declarations were apparently printed at a central location and distributed by van. But after a carload was seized in Isawiyya village near Jerusalem in February 1988 and the local printing press closed down, printing and distribution were decentralized. For example, I obtained two copies of bayan number twenty-three, one in Jerusalem and one in Ramallah. Although the texts were identical, they had been typed on different typewriters and on different size pages. Apparently, one copy had been smuggled between the two cities, and each had reproduced and distributed the copies on its own. Such a method clearly reduced the risks of detection and arrest.

The bayanat set out specific instructions for the coming fortnight: on which days there will be general strikes and demonstrations; hours at which shops should open and close; requests for certain officials to resign; congratulations to particular towns or villages for their efforts. For example, in March 1988, a bayan requested policemen and appointed mayors to resign. Many did—some of them only after threats and attacks, such as the stabbing of the Israel-appointed mayor of al-Bira on June 7—but some had to return to work later since the movement lacks strike funds to help them.

Bayanat include reminders that people should boycott Israeli goods when there are Palestinian-made substitutes. They urge workers to work in Israel only in dire necessity. That policy apparently reflects the result of a sharp debate inside the unified command. I was told in March 1988 that members of the hard-line Popular Front wanted a complete stoppage of work in Israel, but the other groups viewed that as unrealistic since no alternative source of livelihood would be available to many workers. Rather, the unified leadership concluded that in a case where, say, five men in a family had worked in Israel, only one should go. In a village near Ramallah I learned that whereas about two hundred men used to work daily in Israel, now barely fifty commute. An UNRWA employee said that the busloads that used to leave each camp before dawn had dwindled to a couple of taxiloads daily.

People eagerly await the arrival of the bayanat at their doorsteps and follow the instructions carefully. There have been some attempts by Israeli authorities to print false bayanat, but people emphasized to me that they could tell the difference. There is always something suspicious about the wording of the bogus ones, they claimed, or they contain some demand that is apt to cause dissension among the people. In contrast, the authentic declarations express consensus views and are careful to not go beyond the realistic possibilities of mobilizing the public.

PHASES OF THE INTIFADA

Over the years both the goals and the methods of the intifada have evolved. In the early period mass protests were emphasized—large numbers of people pouring into the streets to confront soldiers with stones, burning tires, and barricades. Such large-scale demonstrations, difficult to sustain for many months, gave way to cat-and-mouse tactics. A group of youths would set up a makeshift barricade, which would attract a military patrol. The soldiers would shoot at the youngsters, who would scatter. Meanwhile, a similar incident would occur somewhere else. Alternatively, a jeep with soldiers would station itself in the middle of the vegetable market in a refugee camp, flaunting its authority while the residents hurried to shop in the morning. After a while, its presence would heat up the atmosphere. Boys would start pelting it with stones and the soldiers would leap out, shooting in all directions as they chased the children down the alleys, beating them and shooting volleys of tear gas into the market area. The youths have aimed to keep the military off balance, to harass them, and to minimize their own casualties.

In May and June 1988 the organizers also burned Israeli property. Large areas of Palestinian orchard had already been uprooted by the army, and Arabs retaliated by burning Israeli pine forests, pastures, and fields. June 23 was the "day of arson," when eight brushfires swept 20 acres in north and central Israel. According to the Jewish National Fund, by that date 36,000 acres of forest and pasture had been destroyed.

In early summer, the intifada appeared to lose momentum. Enthusiasm flagged as the deaths and injuries continued without any political results

and as the hot weather turned the refugees' tin-roofed shelters into furnaces during curfews. Nevertheless, during that time the structure of local committees was put most solidly in place, significantly enhancing the ability of the intifada to organize.

Moreover, Israel inadvertently helped to rekindle widespread protests by three actions. First, the government reopened the schools, bringing together thousands of young people daily for political discussions and protests. The swift upsurge in demonstrations caused the government to close the schools in late July rather than keep them open throughout the summer as it had originally intended. Instruction afterward remained sporadic; schools were shut frequently for varying periods and most universities remained closed, the campuses sealed.

Second, the military authorities alienated the solidly middle-class and largely Christian community in the Bethlehem area by the rough measures adopted against its most prominent citizens. At 4:30 A.M. on July 7, 1988, some five hundred soldiers entered Bayt Sahur—a small town that merges with Bethlehem and contains the Shepherds' Field pilgrimage site—and besieged the homes of fifty leading residents, seizing identity cards and impounding cars. They argued that the residents had withheld income tax, vehicle registration fees, and other taxes. They summoned residents to the town school, where tax officials would assess the amounts and collect the revenue. In response, the whole town rose in protest. Nearly five hundred residents turned in their own identity cards, and no one went to the school to be taxed. The military then clamped a ten-day curfew on the town. On the day it was lifted, the main square filled with demonstrators waving Palestinian flags. Church bells pealed, and soldiers

charged into the crowd, killing a teenager. Bayt Sahur was sealed off for another two days, but the disturbances quickly spread to nearby Bethlehem and Bayt Jala. By then, some thousand residents of the three towns had been jailed and the rest were boiling with anger. (A year later, the army sealed off the town for forty-two days and seized furniture, tools, and goods from homes and shops in a brutal confiscation of taxes.)

Third, in the Muslim quarter of the Old City of Jerusalem, the Israeli archaeological authorities began to excavate a tunnel from the edge of al-Haram al-Sharif (the Temple Mount) to the Via Dolorosa. Islamic officials decried the dig as threatening the foundations of the Haram and as a new example of the Israeli effort to gain control over those sacred precincts. Mass demonstrations were held on the Haram and in the stone streets of the Old City. They extended to the residential neighborhoods outside the walls, and a young man was killed in the distant suburb of Bayt Hanina. Since he was the first "martyr" inside Jerusalem—and the first Christian shot dead in the city—the act had a special symbolism. By the end of July, Jerusalem was transformed into a key center of protest, ignited by the Israeli dig.

OBJECTIVES

The cat-and-mouse tactics, daily strikes, house demolitions, and deaths continue. After three years the intifada has generated bitter and deadly patterns of behavior that distort all lives. It has also generated a grim determination not to return to the status quo ante and to hold out instead for a fundamental political transformation. The goals of the intifada expanded as time passed. At first, interim aims were stressed. At a press conference in Jerusalem in mid-January 1988, community

leaders presented a fourteen-point memorandum that emphasized ameliorating the conditions of occupation. It called for the repatriation of deportees, the release of prisoners, the withdrawal of the Israeli army from population centers, and formal inquiries into the behavior of soldiers and settlers. The memorandum also demanded the end to building settlements and confiscating land, the cancellation of Israeli taxes, and the removal of restrictions on building, trade, industry, and agriculture. The memorandum further requested that violations of Muslim and Christian holy places end.

Two of the fourteen points involved political rights: first, to "cancel all restrictions on political freedoms including restrictions on freedom of assembly and association [and to] hold free municipal elections under the supervision of a neutral authority"; and second, to "remove restrictions on the participation of Palestinians from the territories in the Palestine National Council . . . to ensure a direct input into the decision-making processes of the Palestinian nation by the Palestinians under occupation." These political demands were linked to the insistence, stated in the preamble to the memorandum, that an international conference including the PLO be convened to negotiate an end to Israeli occupation and the achievement of peace. Thus the central demands related to undoing the negative effects of the occupation. The long-term goals were self-determination and independence, but achieving them rested largely in the hands of the external powers and the PLO.

The separation between long-range aims and immediate goals, which Israel could adopt unilaterally through direct dealings with the Palestinians on the West Bank and in Gaza, continued until mid-summer. In the spring, the residents of the territories refused to meet with U.S. Secretary of

State George Shultz on the grounds that the convening of an international peace conference could be discussed only with the authorized representative of the Palestinian people as a whole, namely the PLO. However, one Jerusalem journalist commented to me that if the Israeli government had been clever, it would have responded to some of the interim demands, thereby dampening enthusiasm for the intifada. Cancelling the special taxes and restrictions on trade would have satisfied some of the merchants and farmers. Releasing prisoners and reducing the military presence in the towns and camps might have relaxed the atmosphere. In particular, if the government had agreed to conduct municipal elections without any restrictions, then many people would have accepted that concession. In fact, such a move probably would have created divisions within the national movement, as some would have argued for its acceptance and others would have insisted on continuing the intifada until its stategic goals were achieved.

By the time I visited Jerusalem in early August 1988, strategic demands overshadowed tactical ones. That shift came about in part because of the drastic change in King Hussein's position when he announced on July 31 that Jordan was no longer responsible for the West Bank and began to dismantle the administrative and legal bonds that had been in place since 1950. It was also a response to changes taking place within the PLO, as indicated by the document published by an advisor to Arafat, Bassam Abu Sharif. And it indicated the growing confidence of participants in the intifada in their own organizing ability.

The statement by Abu Sharif, although criticized by some other PLO leaders, was viewed as particularly important by West Bank residents. Abu Sharif stated forcefully (and for the first time)

his sense of mutuality with the Jewish people:

Israel's objectives are peace and security. Lasting peace and security are also the objectives of the Palestinian people. No one can understand the Jewish people's century of suffering more than the Palestinians. We know what it means to be stateless and the object of fear and prejudice of the nations . . . [We] know what it feels like when human beings are considered somehow less human than others and denied the basic rights that people around the globe take for granted. (*Jerusalem Post*, June 24, 1988)

In his call for "a free, dignified and secure life not only for our children but also for the children of the Israelis," Abu Sharif asserted the right of both the Jewish and Palestinian peoples to self-rule in a peaceful, cooperative environment. Since "no one can build his own future on the ruins of another's," he called for direct talks between the two sides. He argued that a lasting peace could not be imposed from the outside and could not be achieved by talks through third parties. The mandated representatives of Israel and the Palestinians should meet together. If they did, he said, the two sides could "reach a satisfactory settlement . . . in a month." But if anyone doubts that the PLO really represents the Palestinians, the PLO will agree to "an internationally supervised referendum in the West Bank and the Gaza Strip and allow the population to choose" the PLO or any other body to represent it.

Furthermore, if there are doubts that a Palestinian state alongside Israel would be democratic, then the PLO will "be open to the idea of a brief . . . transitional period during which an international mandate would guide the occupied Palestinian territories to democratic Palestinian statehood." Finally, once statehood is achieved, the Palestinians would welcome "international guar-

antees for the security of all states in the region, including Palestine and Israel." Such guarantees could include "the deployment of a UN buffer force on the Palestinian side of the . . . border."

Abu Sharif's public statement was extraordinary. For a senior PLO spokesman to mention direct talks, a referendum, and international forces would have been anathema earlier. Most Palestinian activists on the West Bank and in Gaza agreed with the content of his statement. They regretted, however, that it had not been issued as a resolution of the PLO Executive Committee. That would have given it greater force and would have undermined the ability of dissidents to criticize it.

In fact, the mounting concern in the territories about the PLO's ability to take a strategic step toward peace appears to have been a key factor in galvanizing local leaders to formulate their own peace proposal. They saw Syria support the Abu Musa forces in Lebanon in ousting Arafat's men from the refugee camps, another reminder of the grim impact of inter-Arab divisions on the Palestinians. They saw Arafat waffle when key members of the PLO criticized Abu Sharif's statement. And they saw the wealthy Arab rulers refuse to contribute to the struggle in the occupied territories despite their pledges at the special summit in Algiers in June. Moreover, they saw Shultz's initiative falter in the face of Shamir's intransigence, Peres's hesitation, and Hussein's and Mubarak's inability to organize a united Arab stance behind the American effort. With the short-term prospects for convening an international conference dim, and with the United States still caught in its demand that the PLO recognize Israel and accept UN Resolution 242 before the United States would negotiate with the Palestinian representatives, the time seemed ripe for a Palestinian initiative that would alter the terms of the debate

and capitalize on the new reality created by the intifada.

This initiative was articulated in the program of action that the Israeli security apparatus seized from the office of Faisal Husseini, the director of the Arab Studies Society and the heir of the leading nationalist family in Jerusalem. Husseini had been placed under administrative detention on July 31, 1988, for the second time during the intifada and shortly after he had addressed a Peace Now rally in Tel Aviv. Soon after, his office was sealed and searched, with every shred of documentation removed—including historical files and computer disks. One of the documents seized was a draft proposal calling for the creation of an independent Palestinian state.

Aware that the security men would soon discover and reveal the document, Palestinian activists passed a summary of it to an American journalist. The document was publicized in the *Los Angeles Times* a day before Israeli TV revealed its existence. In that manner the Palestinians ensured that an accurate version was published. Similarly, on August 12, the *Jerusalem Post* published an English translation of the document, obtained from Palestinians.

The document proposed that it was time for the Palestinians to move from the phase of violent confrontation to the phase of political initiative. That would change the issue of international debate from the PLO's recognition of Israel to the recognition of the Palestinian state established on land occupied by Israel. For once, the Palestinians would force a fait accompli on Israel as well as on the Arab countries and the world. The declaration of independence would be based on UN Resolution 181—the original partition plan of 1947. That would give it international legitimacy and would underline the intention to establish a Pales-

tinian state alongside Israel rather than replacing it. The final borders, however, would be the result of negotiations. (Husseini explained to a fellow Palestinian: every time Israelis talk about retaining parts of the West Bank, we will talk about the 1947 lines, until we can reach a reasonable agreement. The 1967 lines are probably the ones that the international community will endorse, but mutually agreed adjustments are certainly possible.)

Furthermore, the document specified that the PLO establish a two-part interim government. One part would be outside the territories, the other inside. The interim executive body outside would transform the PLO Executive Committee into a government, with Arafat as the head of state and Faruq Qaddumi as the foreign minister. The leaders of the Popular Front and Democratic Front, George Habash and Nayif Hawatmeh, would also be included in the government. The PNC would be expanded into a parliament that would include 152 prominent individuals from the occupied territories, thereby linking the inside with the outside. The internal organs would be composed of the West Bank and Gaza members of the parliament and an interim administrative body, drawn from the legislative members. The administrative body would establish a hierarchical state apparatus dealing with matters like health, education, and the economy and would coordinate with the existing local popular committees. (Palestinians with whom I discussed the plan said that they assumed that in practice the legislative body would never meet, but the 152 members would be consulted by the administrative authority on policy matters. Presumably, Israeli restrictions would make it impossible for the legislature to convene, and for a time the administration itself would have to function underground.)

Once the interim institutions were formed and

the PLO was established as an interim government (rather than a government-in-exile or a liberation movement), the Palestinians would seek to enter negotiations with Israel under the rubric of an international conference. A delegation consisting of individuals from inside and outside the territories would negotiate such issues as the final borders, the future of Jewish settlements, and the resolution of the refugee problem. Immediately following Israeli military withdrawal from the West Bank and Gaza, elections would be held for a government and president, on the basis of a multiparty republican system.

This ambitious plan was due to be issued a week before the next meeting of the PNC. The idea was that the PNC would endorse the declaration of independence and start to seek diplomatic recognition from a wide variety of states. In a sense, the document was a bold plan to force the hand of the PLO. The leaders outside would no longer be able to vacillate once they were presented with a clear, precise document drafted by the leaders of the intifada. Even the rejectionists, it was assumed, would have to back the plan, in recognition of the sacrifices made by the Palestinians in the occupied territories.

The premature disclosure of the plan caused some discomfort, in part because the document was still a draft and in part because the names of the 152 proposed legislators fell into the hands of Israeli security forces. Nevertheless, it came just after King Hussein's dramatic withdrawal and helped to crystallize thinking among Palestinians about their own future. It compelled the Israeli and international publics to recognize that a credible peace plan was being drafted by the Palestinians themselves. And it served notice on the PLO that the people in the territories were prepared to take the initiative, pulling the PLO along with them.

Thus within nine months the intifada gave birth to a proposal for an independent state. The Palestinians were no longer willing to accept interim measures that would merely improve their conditions. The PLO leadership responded rapidly to the West Bank initiatives. The PNC session in November 1988 endorsed the establishment of an independent state on the West Bank and in the Gaza Strip, with UN Resolutions 181, 242, and 338 as its legal underpinning. Arafat affirmed the right of both Israel and Palestine to live in peace and security. Those historic moves marked the political high point of the intifada. Palestinians solemnly pledged their support for the comprehensive resolution of their problem, a resolution that would establish Palestine alongside Israel. They hoped that would transform the relationship between the two intensely nationalistic peoples from one of bitter antagonism to one of pragmatic mutual acceptance.

ISRAELI REACTIONS

The Israeli government and public were caught off guard by the intifada. Defense Minister Yitzhak Rabin reacted by intensifying his policy of the Iron Fist. He argued that using the strongest force possible against demonstrations would end the riots swiftly and convince the public to resume a normal life. When the populace continued to confront live ammunition with stones and taunts, Rabin announced in January 1988 that the soldiers would break the arms and legs of demonstrators. That would prevent them from returning to the streets and would reduce the number of deaths. The armed forces also enforced lengthy curfews, demolished houses, threw tear gas into homes,

and detained more than five thousand persons. That represented an intensification of prior practices.

To establish control effectively, Rabin had to increase the military presence in the territories nearly tenfold. Whereas fewer than a thousand soldiers had patrolled the Gaza Strip before 1987, now nearly ten thousand are camped there. Similarly, the number of soldiers on the West Bank expanded from about seven hundred to nearly eight thousand, according to UN sources. Soldiers specialized in artillery or antiaircraft fighting had to be sent to patrol the streets, despite their lack of appropriate training and the resultant weakening of their training programs in their specialized fields. Annual reserve duty for men was increased from the normal thirty days to sixty-two days. (In contrast, at the height of the fighting in Lebanon, reserve duty extended for forty-five days.)

The government tried to put economic pressure on the Palestinians. Soldiers prevented villages from selling their ripe fruit abroad and either forced shops to open or forced them to close. The government imposed new taxes on the residents for IDs, car licenses, and even donkey carts and compelled them to pay income taxes in advance. Courts fined house owners and parents for graffiti on the walls and stone throwing by their children. Nevertheless, the response of a pharmacist in Bayt Sahur was typical: although he had lost half his income, he said, "I will take on my shoulders as much as I can to alleviate the lives of my sons. I believe in the future—I believe that my sons should live freely. If I have to sacrifice now, OK" (quoted in the *Washington Post*, July 26, 1988).

Meanwhile, the Israeli economy itself was squeezed by the costs of the intifada and by the loss in revenue that it entailed. The U.S. Embassy estimated in the summer of 1988 that additional

military and police expenditures were running at $120 million a month. Moreover, the indirect cost in lost tourism, decreased sales of Israeli products to the Palestinians, and lowered production as a result of fewer Arab workers was estimated at $38 million a month. Although the government hesitated to issue figures on the costs, the minister of economy admitted that $600 million had been lost in tourism, exports, and production in the first six months of the intifada.

Within Israel, the intifada has further polarized views on the future of the territories. Polls indicate that those already seeking to retain the West Bank and Gaza and determined to reject the idea of Palestinian self-rule are now hardened in their views. Some even advocate the expulsion of the Palestinian residents, cloaked under the neutral term *transfer*. Those already seeking a territorial compromise and a negotiated settlement with Palestinians and Jordan, however, also feel reinforced in their views. The long-term danger to Israel's demographics and democratic values seems more pronounced to those Israelis than it did before. There is a proliferation of peace groups, including a small band called Women in Black. I watched their Friday vigil at a busy intersection in Jerusalem in August 1988. Standing with placards reading End the Occupation, a hundred women silently witnessed against the army's actions. Some passing drivers shouted insults at them, and a cluster of hard-line Tehiya supporters waved their banners across the street. But others stopped to thank them and to ask if they could join the vigil the next week.

Prime Minister Shamir plays to the fears of Israelis in his statements. After an Israeli farmer was killed, he said: "We stand before a wild and murderous phenomenon, the fruit of fanatical hatred that seeks the death of all citizens of Israel" (Reu-

ters, June 24, 1988). Soon after, he argued that the conflict "does not revolve around a territorial issue—the attack is on our existence" (*Jerusalem Post*, July 8, 1988). Thus he publicly rejects the idea that the intifada is directed solely against the occupation. By reviving Jewish fears of annihilation, Shamir seeks to block territorial and political compromise. At most the prime minister will consider a limited Palestinian administration in the West Bank and Gaza, based on the concept of autonomy presented at Camp David.

The former foreign minister Shimon Peres spoke explicitly of territorial partition. However, he stressed that King Hussein would play the leading role, with the Palestinians from the West Bank and Gaza as junior partners. The king's withdrawal of responsibility for the West Bank on July 31 undercut the logic of Peres's plan. Subsequently, even though Peres himself clung to the hope that the king would return to the negotiating table, the bureau of the Labor party drafted a new position. It called for negotiations both with Jordan, about issues involving their common border and the achievement of peaceful relations, and with the residents of the West Bank and Gaza about the future of the territories. It separated the issue of Jordan from that of the occupied territories for the first time since 1967.

If the intifada has compelled Israeli politicians to begin re-evaluating their stances on the future of the West Bank and Gaza, it has probably been most remarkable for its impact on the thinking among officers in the armed forces. Although polls indicate that the Israeli public in general supports a strong-arm policy to quell the uprising, doubts have surfaced among the officers. A military correspondent for *Yediot Ahronot,* a right-leaning newspaper, wrote in June 1988 that 80 percent of the generals currently in service believe that the

consequences of holding the land will be much worse strategically than those of giving it up. That perspective was echoed in a poll taken the same month among serving generals in the army: 55 percent backed territorial concessions to gain peace and 70 percent stated that making such territorial concessions would not encourage Arab states to go to war with Israel (*Al-Ahrām*, July 28, 1988). Even more pointedly, Chief of Staff Dan Shomron remarked bluntly in July—during a tour through Bayt Sahur, then under curfew:

I cannot say we are controlling the Palestinian will, their aspirations. . . . We are conducting a struggle between us and the Palestinian population. This struggle . . . will continue for years. The real question is, at what level of violence will this struggle be conducted? Our real objective is to lower the level of violence. (Reuters, July 15, 1988)

Although serving officers are not supposed to voice political opinions, retired officers are not under the same restrictions. A by-product of the intifada has been the establishment of the Council for Peace and Security, a nonpartisan body of former Israeli officers. Formed in June 1988, it was quickly joined by 30 reserve generals, 80 reserve brigadier generals, and 150 retired colonels. I talked to one of the founders, the former military intelligence officer Alouph Hareven. He told me that the council members seek to disprove the thesis that holding the West Bank and Gaza is essential for Israeli security. The members argue that the West Bank provides no strategic depth for Israel today, given the nature of modern warfare. Rather, relinquishing most of the land in a peace accord would provide the best defense against renewed war. Given the respect with which com-

manding officers are viewed by the Israelis, the willingness of those generals to launch a campaign of public education is a significant outcome of the intifada.

PROSPECTS

The basic Israeli-Palestinian conflict remains unresolved three years later. As in an elaborate multidimensional chess game, each side maneuvers warily. Each party tries to make a move that will simultaneously maintain the support of its members, enhance its strategic position, and resolve its existential needs. Moreover, the parties are not monolithic: contending forces within the Palestinian and Israeli communities pull them in different directions.

Nonetheless, the moves made by the Palestinians on the West Bank and in Gaza to challenge the status quo and to articulate their interim and long-range goals transformed the political equation in the region. Israeli political forces were compelled to react to the Palestinian drive. They could no longer assume complacently that the status quo would continue indefinitely. The United States also had to respond to the new reality. Reliance on King Hussein as the linchpin in the region was no longer feasible, and a strategy that took the Palestinian core into account was essential. After painful internal debate, the Reagan administration agreed to start a political dialogue with the PLO, which was the essential first step toward serious peace negotiations.

Nonetheless, diplomatic efforts broke down in June 1990. The United States abruptly suspended the dialogue, citing the PLO's apparent violation of its pledge to end terrorism. More fundamentally, Shamir blocked all efforts by America, Egypt,

and the Palestinians to hold Israeli-Palestinian meetings. Such talks were merely the prelude to elections for a Palestinian delegation that would negotiate the terms of an interim regime on the West Bank and in Gaza. But Shamir did not want to open any door that might ultimately lead to relinquishing territory. The formation of a hard-line Likud government in June wrecked whatever prospects remained for negotiations. Several new ministers openly advocated the expulsion of Palestinians, permanent annexation of the land, and the establishment of Jordan as the Palestinian state. Their views—coupled with the prospect of at least 150,000 Russian Jews immigrating in 1990 alone—terrified Palestinians and Jordanians. It was not surprising that they erupted in a frenzy of anti-Israeli and anti-American demonstrations in August.

Before the intifada, observers assumed that Israel's creeping annexation of the West Bank and Gaza was irreversible. Israel ruled supreme and Palestinians seemed too demoralized to resist. The uprising transformed Palestinian life and challenged Israeli control. But the Palestinians' daily struggle and their diplomatic efforts have still not won them freedom.

George Azar's photographs emphasize Palestinian determination and pride. Despite death, deportation, and the destruction of their homes, the Palestinians uphold their rights. They remain steadfast, convinced that one day the horror of military occupation will end and they will truly live.

The Impossible

Don't ask me the impossible
Don't ask me to hunt the stars
 Walk to the sun
 Don't ask me
 To empty the sea
 To erase the day's light
I am nothing but a man

 Don't ask me
 To abandon my love
 My eyes
The memory of my childhood

I was raised beneath
 An olive tree
 I ate the figs
 Of my orchard

 Drank wine
From sloping vineyards
 Tasted cactus fruits
 In the valley
 More, more . . .

The bluebird has sung
 In my ear
And the free wind of field and city
 Has always touched me

 Therefore my friend
It is impossible to ask me
 To abandon my homeland.

Fouzi al-Asmar

14. A shepherd in his field in Palestine.

15. An olive grove in springtime with a mosque in the far distance, Al-Luban Valley.

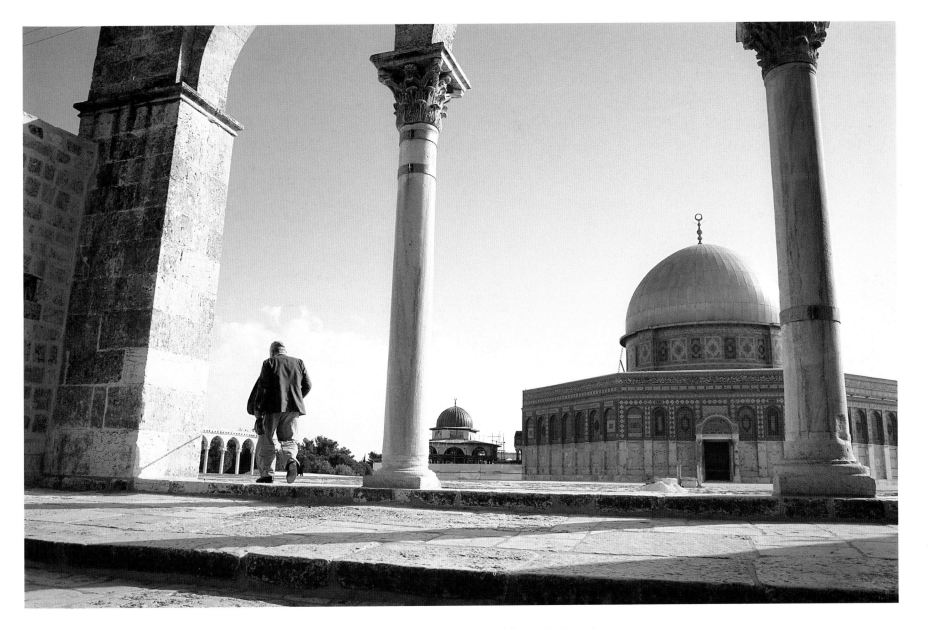

16. A worshiper leaves the Dome of the Rock, Jerusalem.

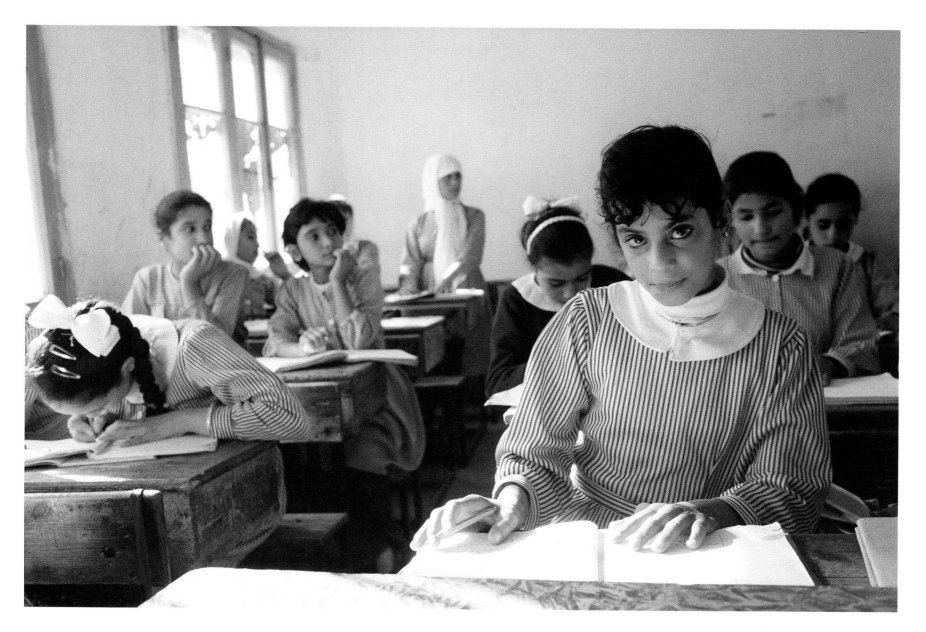

17. An elementary school class in Jabalya refugee camp, Gaza.

Her eyes are Palestinian
Her name Palestinian,
Her dreams and sorrow Palestinian,
Her kerchief, her feet and body Palestinian,
Her words and her silence Palestinian,
Her voice Palestinian,
Her birth and her death Palestinian.

> Mahmoud Darwish,
> "A Lover from Palestine"

18. Tending plants in Acre.

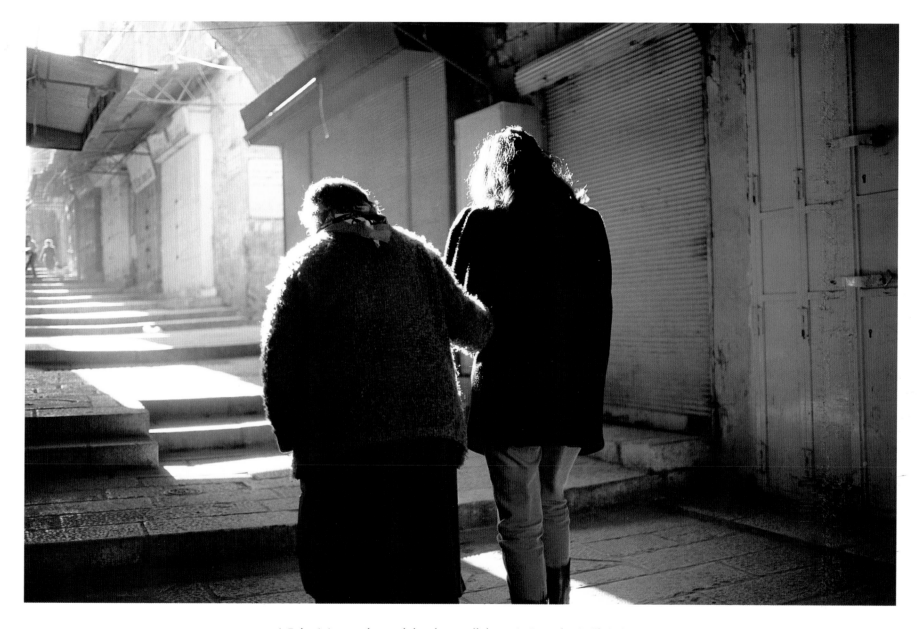

19. A Palestinian mother and daughter walk home in Jerusalem's Christian quarter,
past stores closed by the intifada's commercial strike.

20. Shepherds with their flock.

21. Collecting firewood near Tulkarm.

22. The poet, lyricist, and professor of philosophy at Bir Zeit University
Hussein Barghouti.

23. Praying at Rachel's tomb in Halhul.

It is not as though there was a Palestinian people
in Palestine considering itself as a Palestinian
people and we came in and threw them out and
took their country away from them. They did not
exist.

Golda Meir,
London Sunday Times,
June 7, 1969

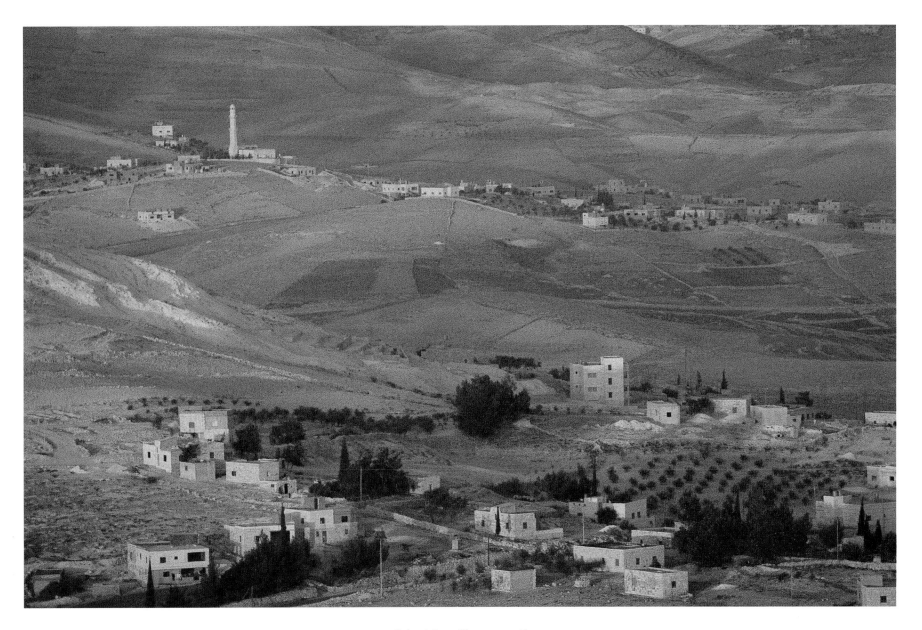

24. Palestinian villages near Zaᶜtara.

25. Cardplayers in a coffeehouse, Haifa.

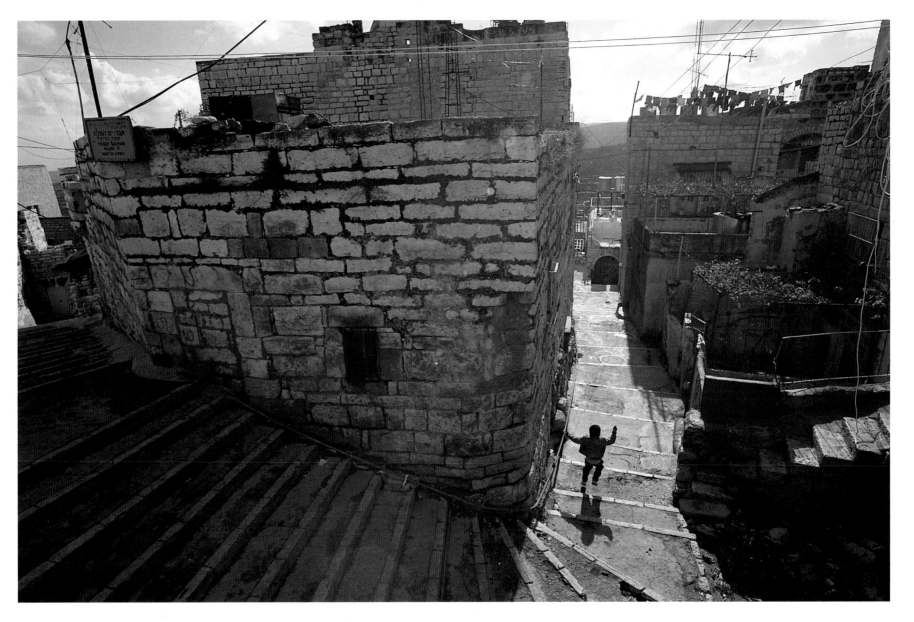

26. Daraj al-alf darji, the staircase of a thousand steps, Bethlehem.

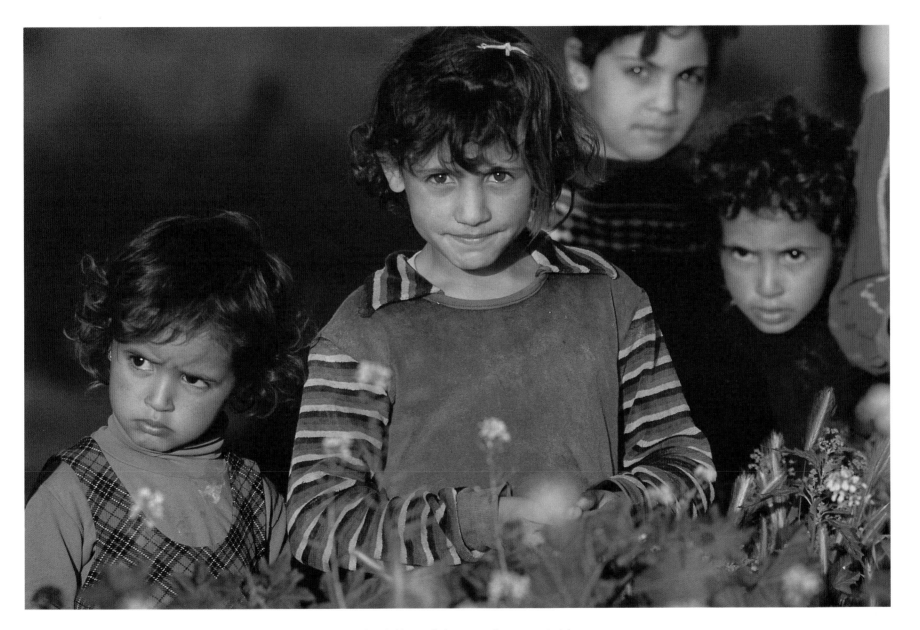

27. The children of al-Uja, a village near Jericho.

Within a short period of time there will be no Jewish workers in Israel. The Arabs shall be the workers; the Jews shall be the managers, inspectors, officials, and policemen and mainly secret service men. A state governing a hostile population of 1.5 to 2 million foreigners is bound to become a Shin Bet state, with all that this would imply to the spirit of education, freedom of speech and thought and democracy. This corruption, characteristic of any colonial regime, would be true for Israel. The administration will be forced to deal with the suppression of an Arab protest movement and the acquisition of Arab quislings. We must fear that even the army and its officers, a people's army, will deteriorate by becoming an occupation army, and its officers, turned into military governors, will not differ from military governors elsewhere in the world.

Professor Yeshayahu Leibovitz,
Yediot Ahronot,
March 1968

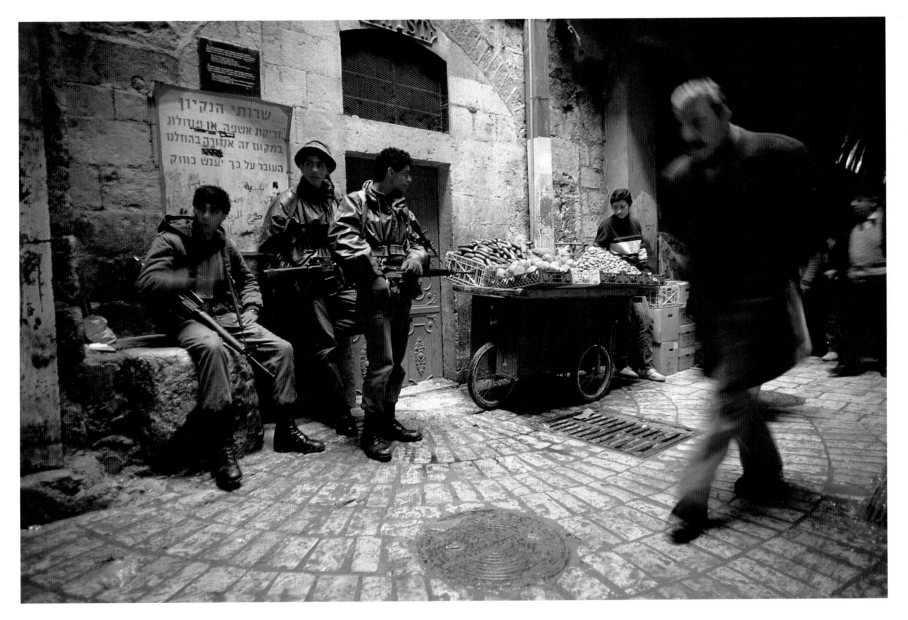

28. Israeli troops stationed in the Palestinian market along Jerusalem's Via Dolorosa,
Christ's road to the Crucifixion.

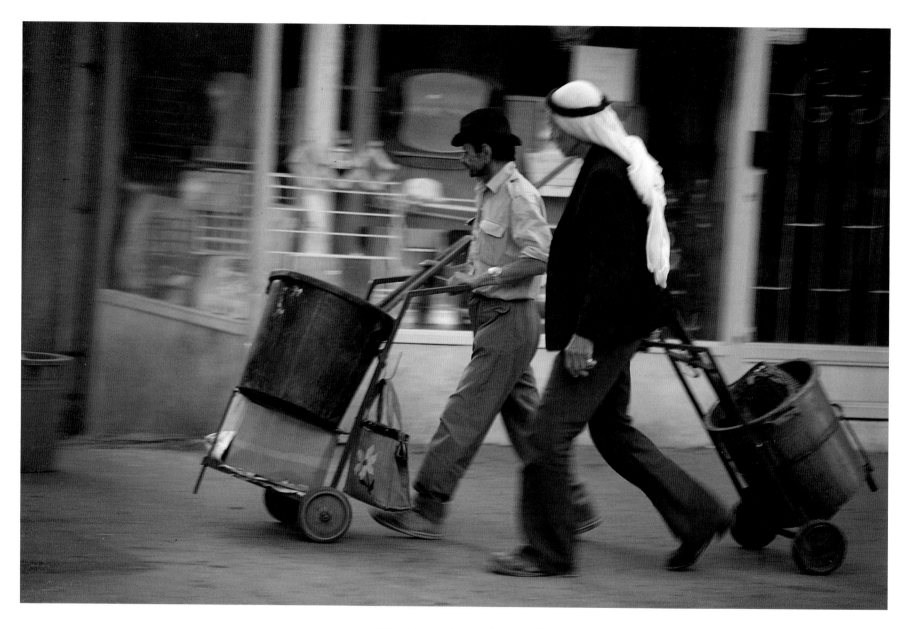

29. Palestinian garbage collectors, Haifa.

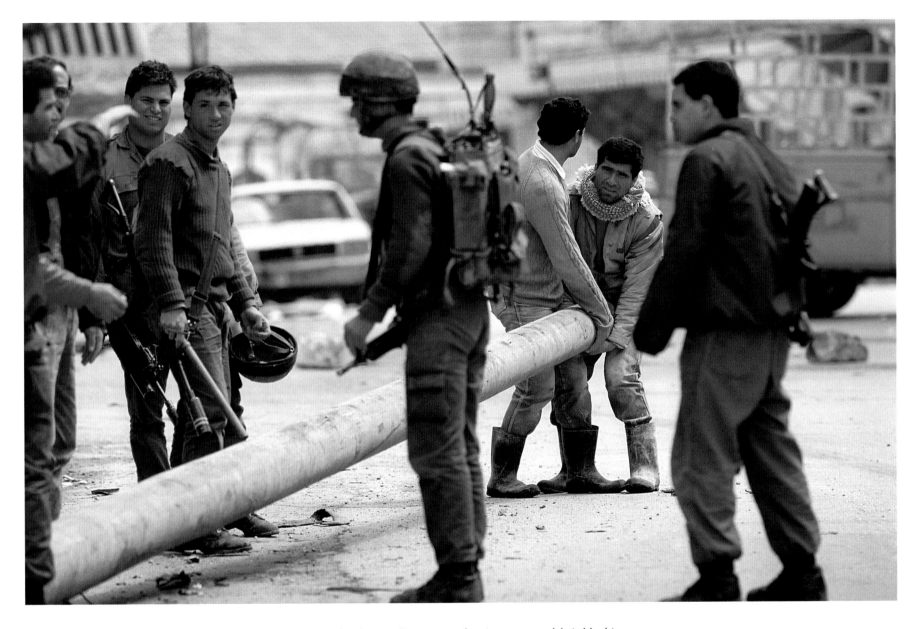

30. Under orders by Israeli troops, pedestrians remove debris blocking a street
after a demonstration.

Put it on the record.
I am an Arab
And the number of my card is fifty thousand.
I have eight children,
And the ninth is due after summer.
What's there to be angry about?

Put it on the record.
I am an Arab.
You stole my forefathers' vineyards
And the land I used to till,
I and all my children,
And you left us and all my grandchildren
Nothing but these rocks.
Will your government be taking them too
As is being said?

Mahmoud Darwish, "Identity Card"

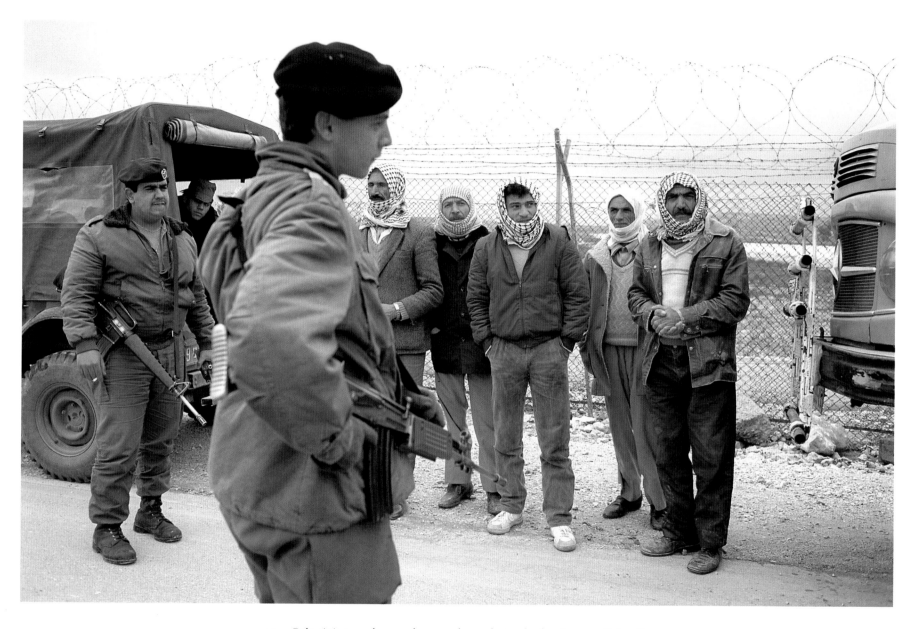

31. Palestinian workers under armed guard at a checkpoint near Kalandia.

If I were to change the names, a description of what is happening in the Gaza Strip and the West Bank could describe events in South Africa. I am against violence, but I am also against repression.

South African Archbishop Desmond Tutu

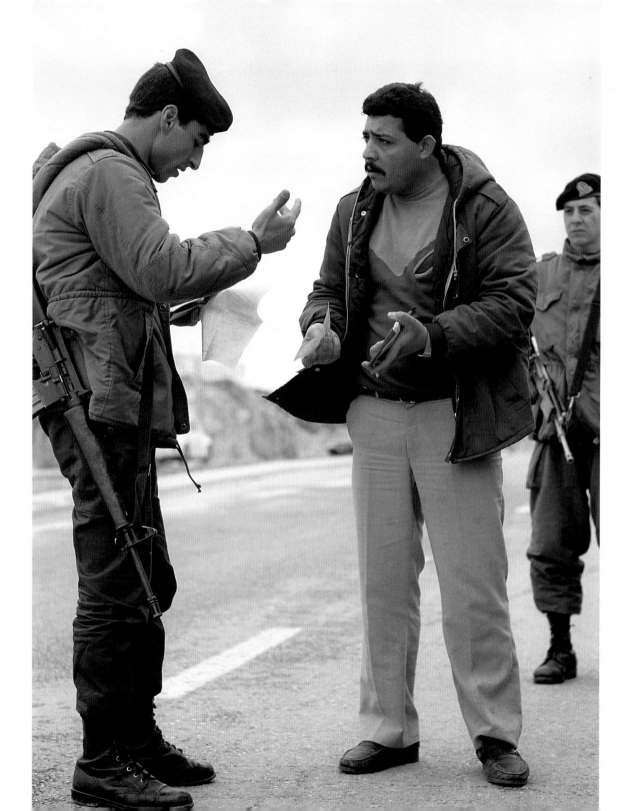

32. Identity card check, Kalandia.

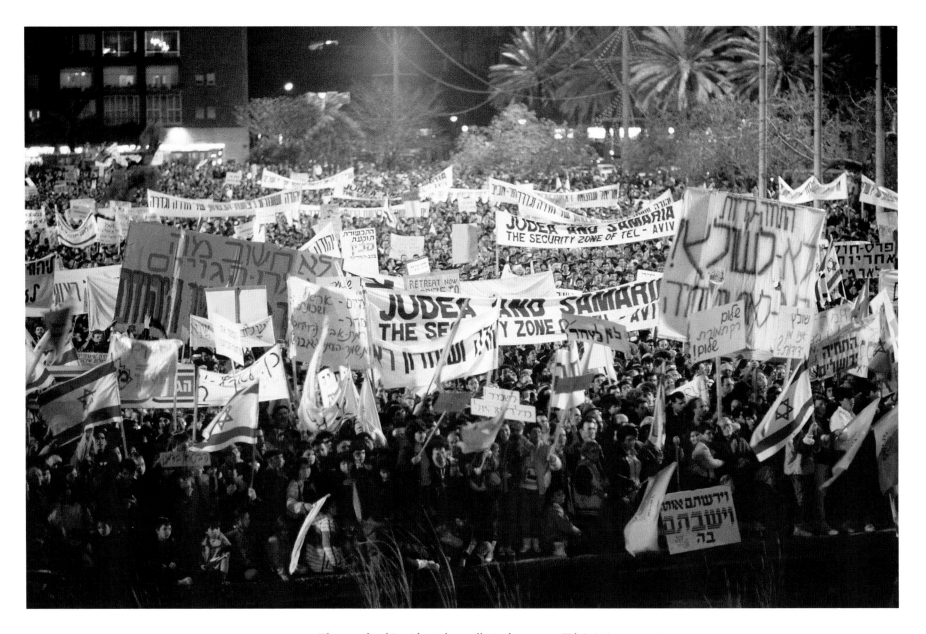

33–34. Thousands of Jewish settlers rally in downtown Tel Aviv in support
of the colonization policies of Israeli Prime Minister Yitzhak Shamir.

We came to this country which was already popu-
lated by Arabs, and we are establishing a Hebrew,
that is a Jewish, state here. . . . Jewish villages were
built in the place of Arab villages. You do not even
know the names of the Arab villages, and I do not
blame you, because these geography books no
longer exist; not only do the books not exist, [but]
the Arab villages are not there either. Nahala arose
in the place of Mahalul, Gevat in the place of Ji-
bita, Sarid in the place of Haneifs, and Kefar
Yehoshua in the place of Tell Shaman. There is not
one place built in this country that did not have a
former Arab population.

Moshe Dayan, *Haaretz* (an Israeli daily
newspaper), April 4, 1969

35. The windows of a Palestinian home in Jaffa,
sealed by the Israeli authorities.

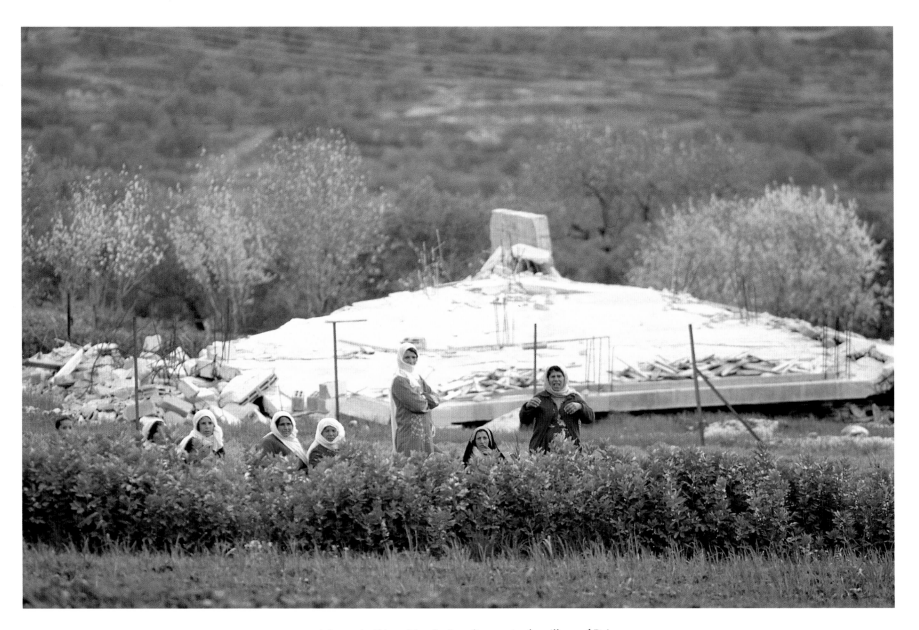

36. A home bulldozed by the Israeli army in the village of Beita.

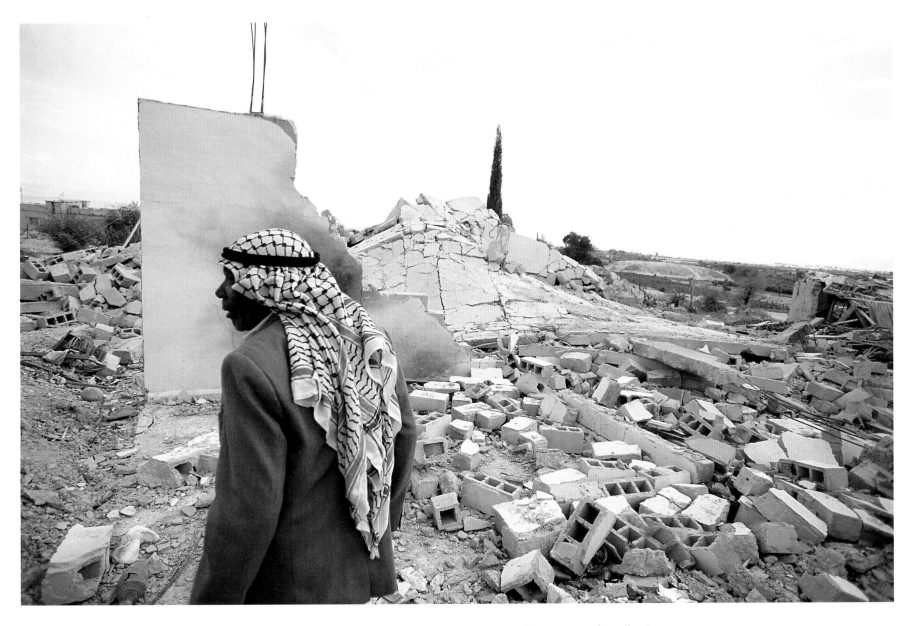

37. The demolition of this man's home was carried out as part of a collective punishment imposed on Palestinians of the Jericho region after a gasoline bomb attack on an Israeli car. Neither he nor any of his family was charged with the crime.

38. Tents pitched on the ruins of the bedouin hamlet Kassan, a small cluster of
houses just south of Bethlehem. At approximately 5 A.M. on October 27, 1988, the
hamlet was razed in an Israeli army operation. According to the villagers, the soldiers
allowed them thirty minutes to remove their belongings before leveling the houses.

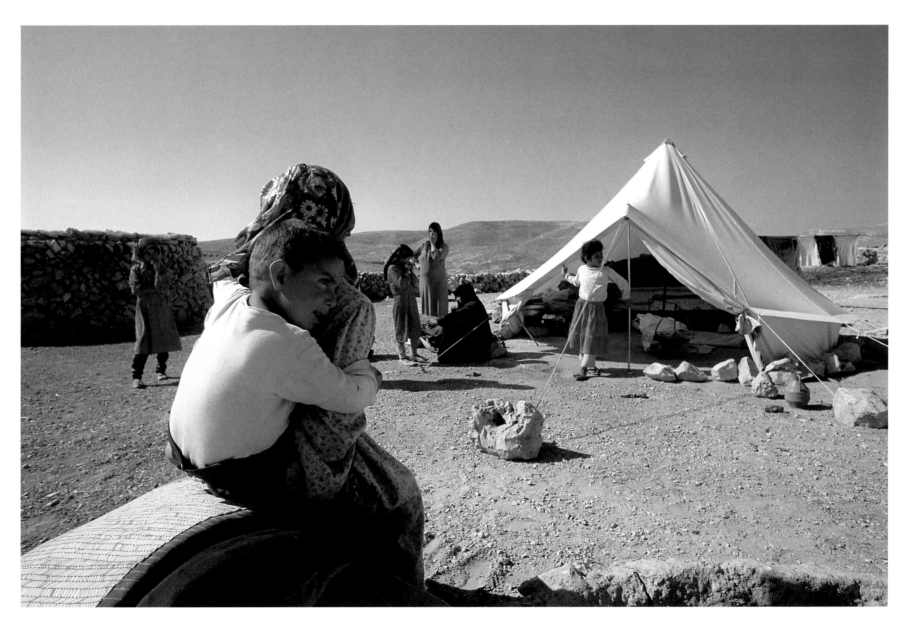

39. A new generation of Palestinian refugees, Kassan.

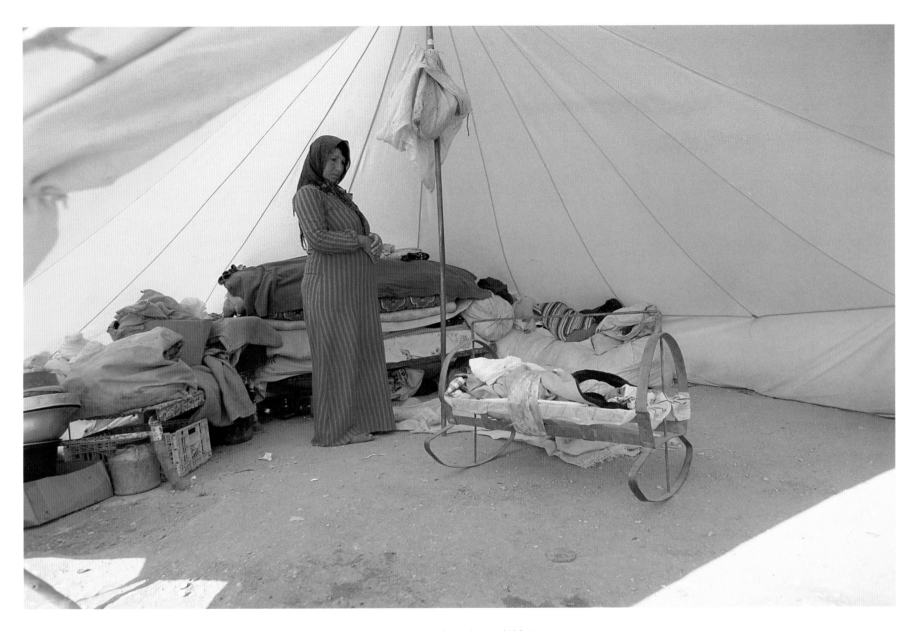

40. Mother and newborn child, Kassan.

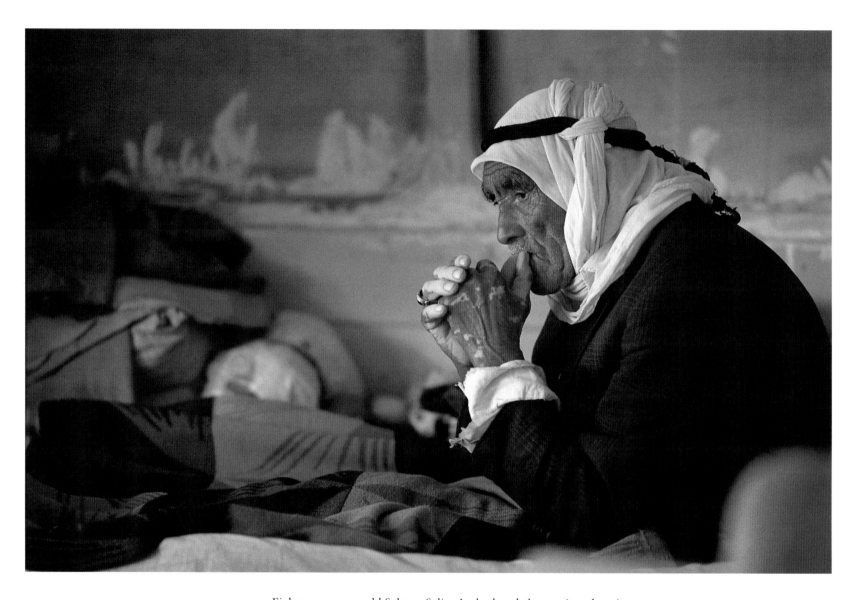

41–42. Eighty-seven-year-old Salman Salim Aral takes shelter against the winter
cold in the rusting school bus where he lives. The decrepit bus near the rubble of his
ancestral home, illegally seized and razed by the army, was given to him by the Israeli
government as compensation. The olive orchard that provided his income was
uprooted. He is destitute and has no source of income.

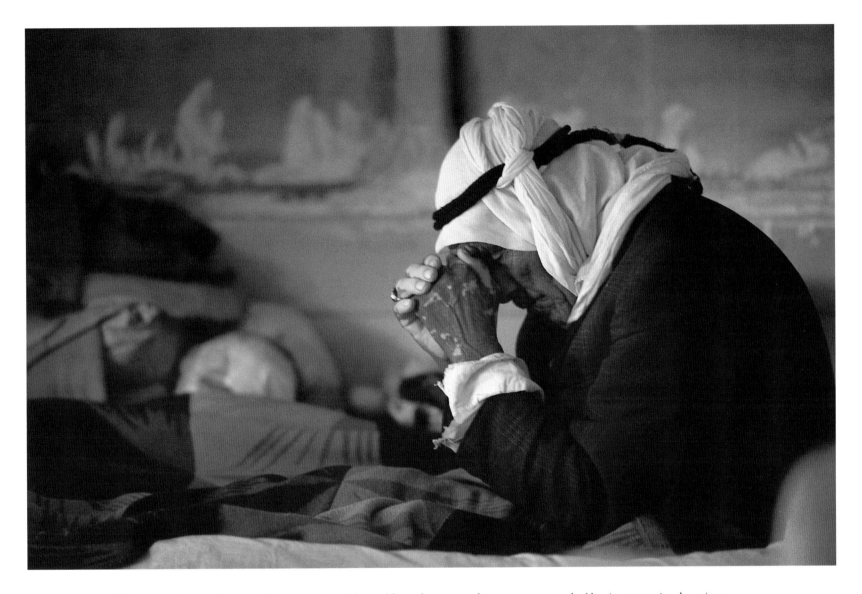

They came into my house with no warning. They told me that my nephew was suspected of having committed a crime. They said I had to be punished. I could not understand everything they were saying because they were talking in Hebrew to each other. They said I had one hour to pack up my belongings and leave the house. When the hour was up, they brought in two bulldozers and destroyed our home. This was my great-grandfather's house, and now it is nothing but a pile of rocks.

Old man near Bethlehem

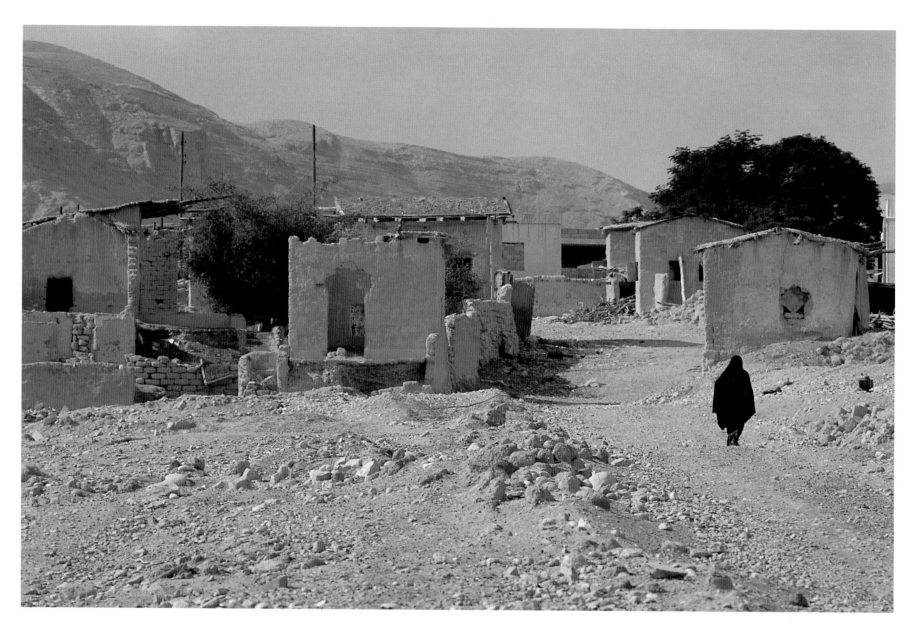

43. An abandoned refugee camp, Jericho.

The key to my house is with me wherever I go.
I always carry it throughout my wandering
in the deserts of grief.

Fadwa Tuqan, "The Call of the Land"

It was raining on March 8th, International Women's Day. The demonstration took place on Salah al-Din street, not far from the National Palace Hotel. The Israelis knew there would be a march, so they were prepared and surrounded the area with Shin Bet agents, the army, and the police.

My mother arrived, along with five other women, from Herod's Gate. She is very enthusiastic about these events, even more than I. She worries, though, about her children being in demonstrations and would prefer to participate alone and to have us remain at home. Once at a march she threw herself in front of me, to shield me with her body.

There were about a hundred women at the Women's Day march. We had to keep on the move while waiting to gather, because the area was full of police and Shin Bet agents. It took thirty minutes for us to finally assemble.

It was very dangerous.

We carried signs and banners about women, prisoners, martyrs, and the deported. Police using bullhorns called to us, ordering everyone to disperse and not block the street. They told us to tear up our banners or else they would do it for us.

We didn't follow their orders.

We hadn't traveled two meters before we were surrounded. The police forced us onto the sidewalk, hitting our legs with truncheons. Then they sprayed gas on us—not out of grenades but directly, through a hose. The gas was so intense I was knocked unconscious. A lot of other women were also knocked out. My mother nearly died of suffocation, and her lungs are permanently damaged. Six women were arrested. The other women carried the unconscious to a nearby home, then to the hospital.

I don't remember anything else of that day, but the other women told me that half an hour later, life on Salah al-Din street was back to normal.

Randa Jabari, seventeen years old,
Old City of Jerusalem

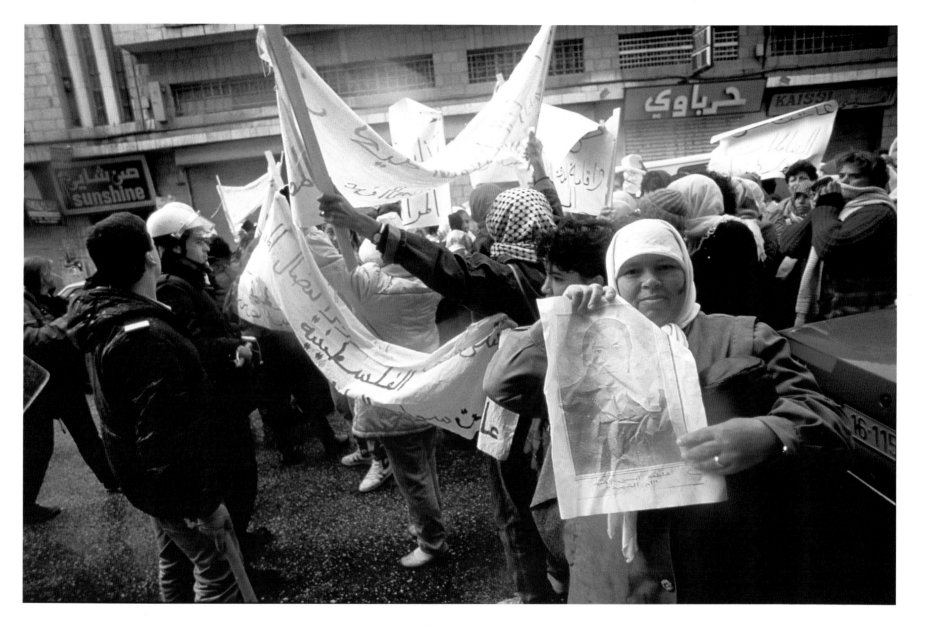

44. A woman among the assembling marchers in Jerusalem holds a photo of a woman
killed by the Israeli military.

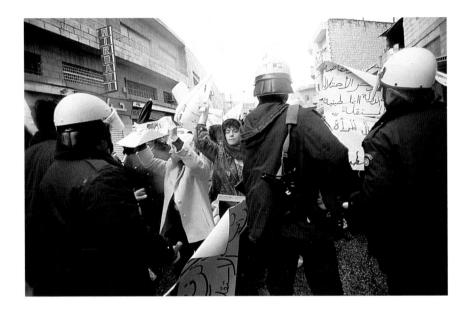

45. Police surround the marchers as they attempt to walk down Salah al-Din street.

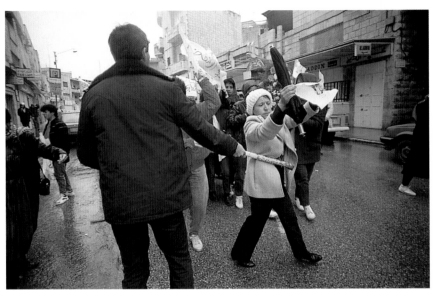

46. Using wooden truncheons, the police begin to force the women onto the sidewalk.

"May start fires. Must not be sprayed directly on humans or in a confined space as death or injury may result."

The warning label on gas canisters used by Israeli forces

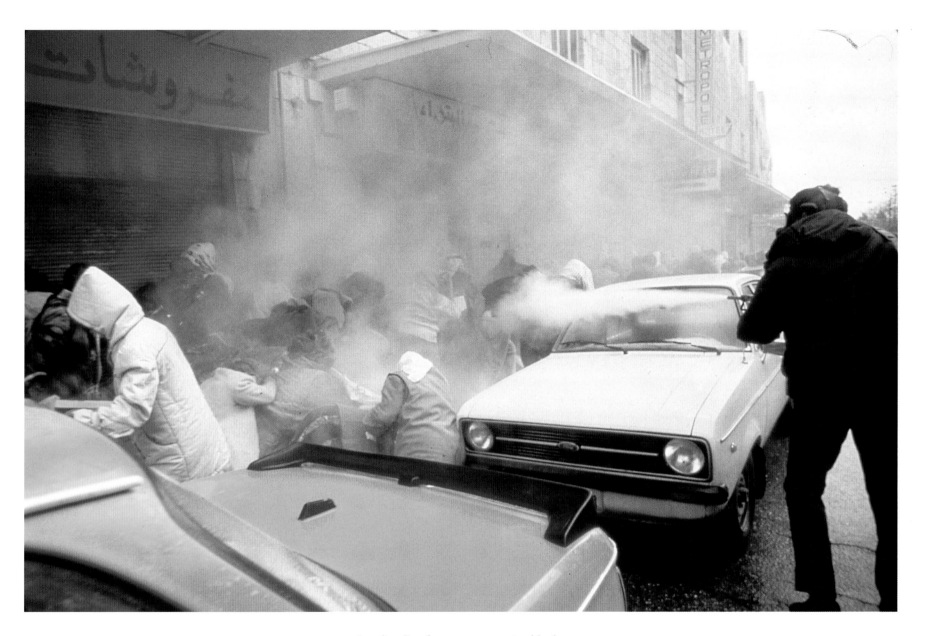

47. Israeli police fire tear gas at point-blank range.

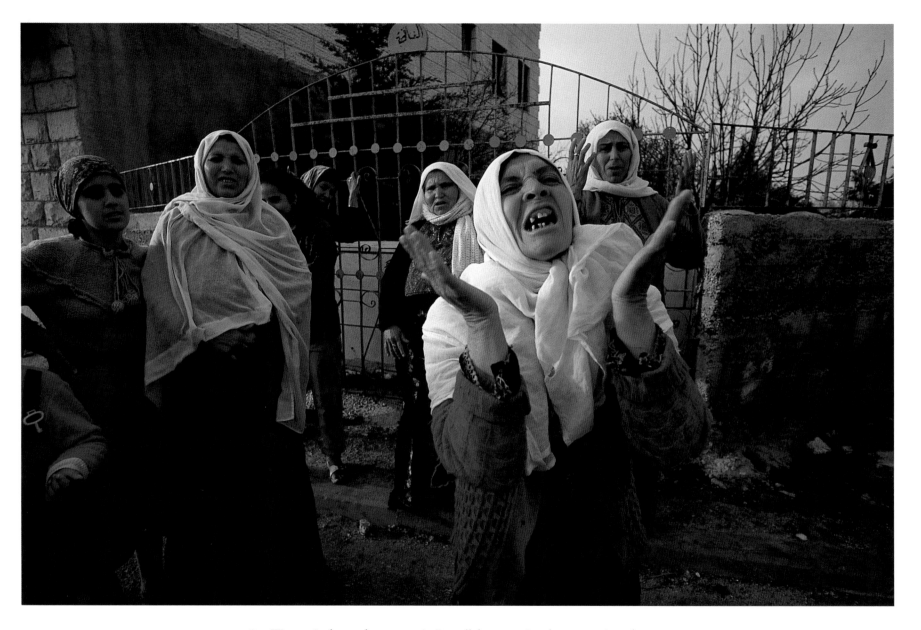

48. Women in front of a mosque in Ramallah, protesting the teargassing of women
during another demonstration.

5 THE UPRISING

We affirm that our people in the occupied territories have launched a genuine popular uprising against an illegal military occupation. The events we witness daily in our towns, cities, and refugee camps are not, as Israeli spokesmen claim, "incidents of rioting and public disorder." Rather, an entire people—the young and the aged, students, merchants, workers, and professionals—is acting to reclaim our national and human rights in order to live in freedom and dignity. With one voice, the Palestinian people demand an end to the military occupation and the establishment of an independent Palestinian state under the leadership of our sole legitimate representative, the Palestine Liberation Organization.

Excerpt from an open letter
from the educational community
in the occupied territories

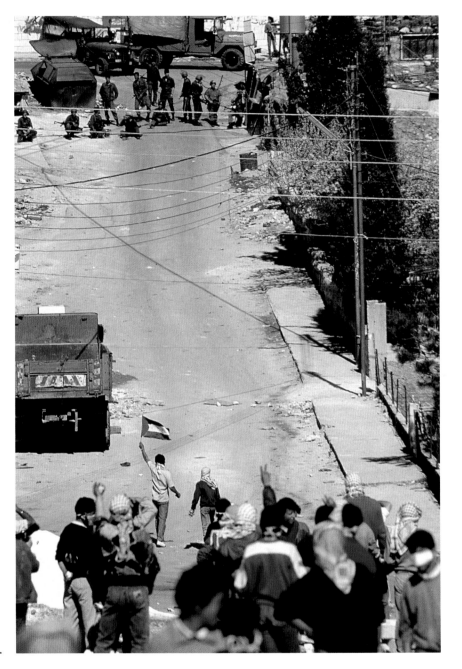

49–51. Prelude to a skirmish in Ramallah.

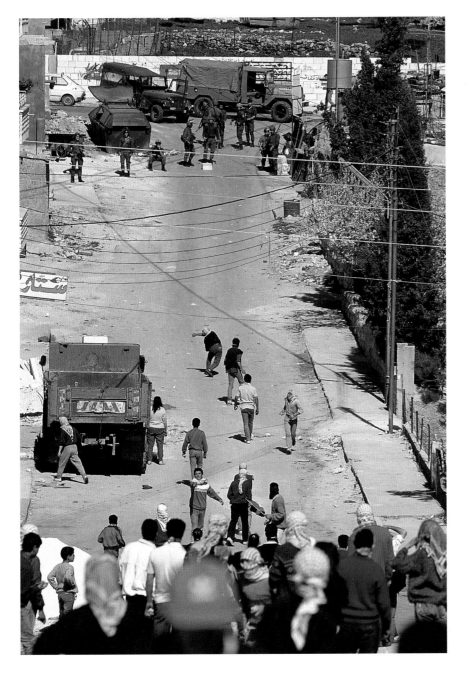
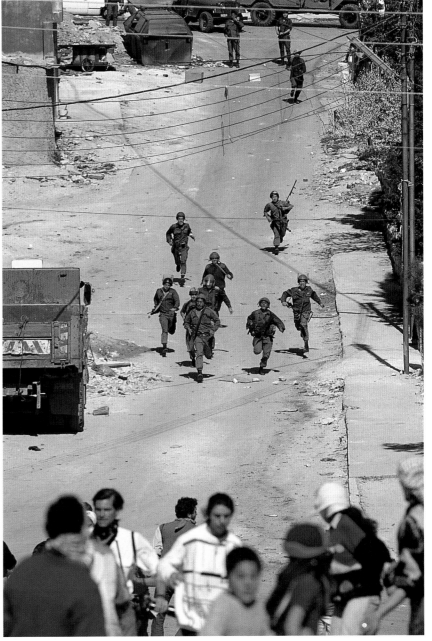

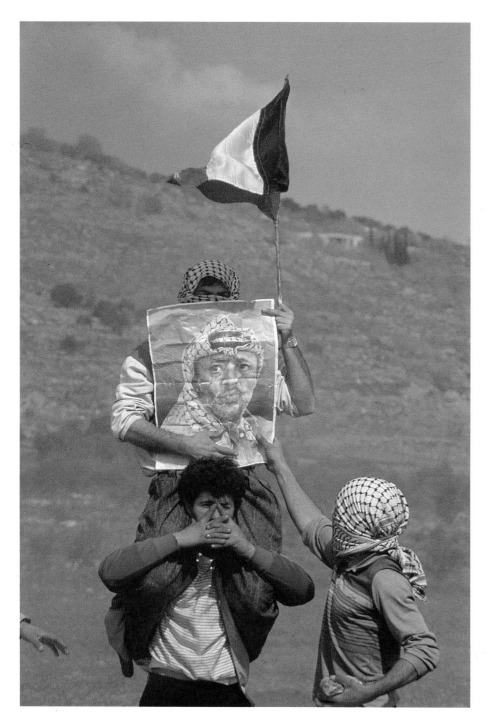

52. Palestinian *shabāb*, "young men."

Bayt Sahur is a town near Bethlehem. Our townspeople are well educated; our men and women are very strong, as are our young.

Since the occupation began in 1967, everyone in Bayt Sahur has become unhappy with the military presence here. The truth is, we would all like our independence, to have our own government, to be able to hold our own opinions and maintain our traditions.

We want to be able to walk down the street with our children, in any way we please, without anyone's objections.

We were, of course, very happy when the intifada started in Gaza. Although we had not experienced the same hardships as the people of Gaza, we wanted to show the Israelis that we are a single nation. We wanted to show them that we have brains and feelings and that like them we are also the children of God.

Soon after the intifada began, the town of Bayt Sahur rose up and lent assistance to Gaza, sending contributions of food and milk by truck. After a month and a half we started our own demonstrations, each Sunday after Mass, to express what we felt inside.

From week to week we would look forward to Sunday's demonstration. And I can truthfully tell you that every woman, before putting her head on the pillow Saturday night, finished all her cooking, all her cleaning, all her washing—the pots, the pans, the utensils—and her ironing and made sure that she didn't have any work on Sunday so that she would be free to march, hand in hand with the young, holding our banners and flags.

We were on fire waiting for Sunday.

Jamila Comsia
Bayt Sahur, December 1988

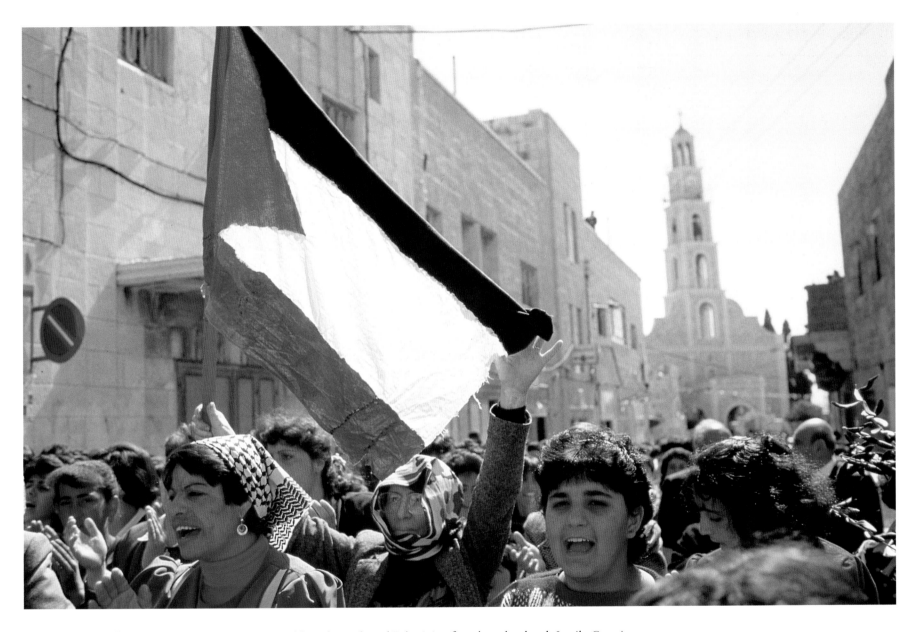

53. Holding the outlawed Palestinian flag above her head, Jamila Comsia emerges
from Sunday church service.

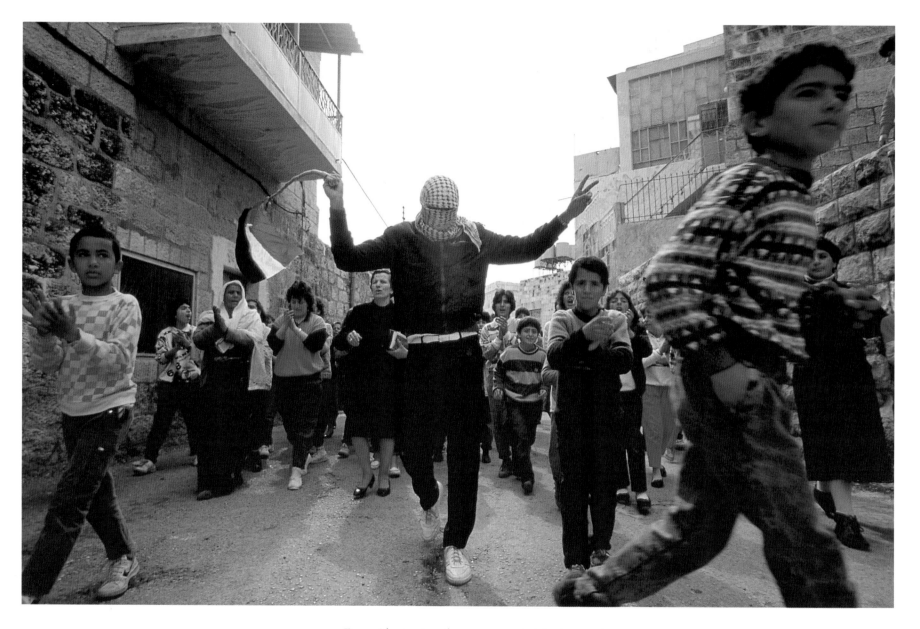

54. From side streets, other townspeople join the march.

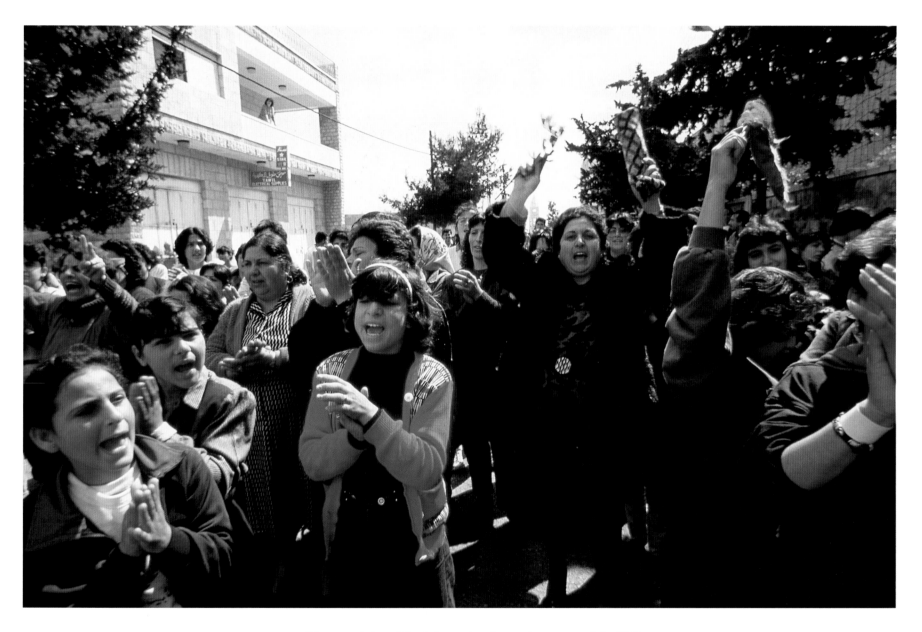

55. The crowd sings Palestinian national songs in support of the PLO.

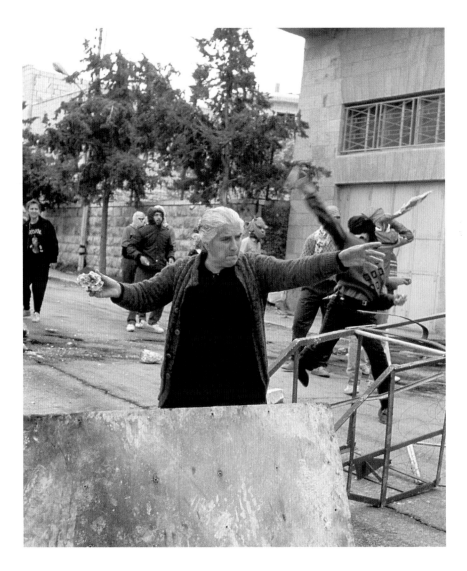

56–58. At the barricade.

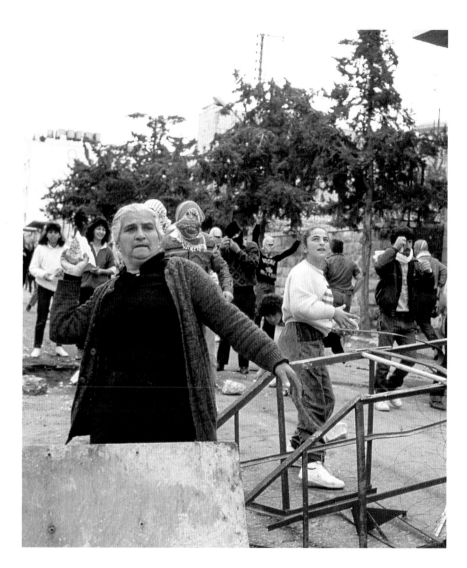
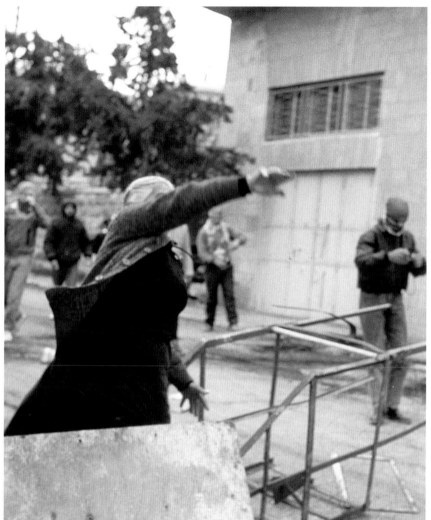

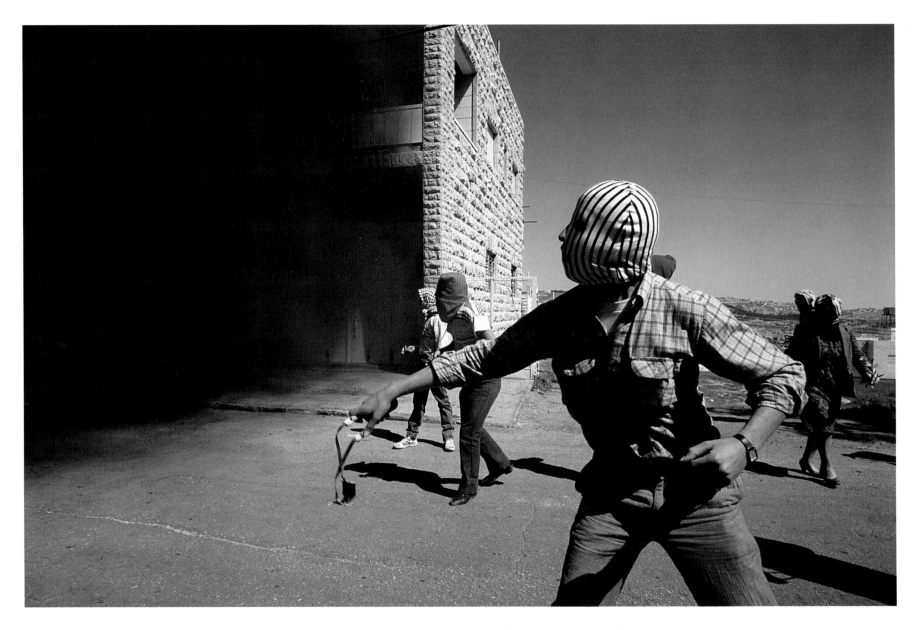

59. A young man firing a slingshot from behind the dense black smoke
of burning tires.

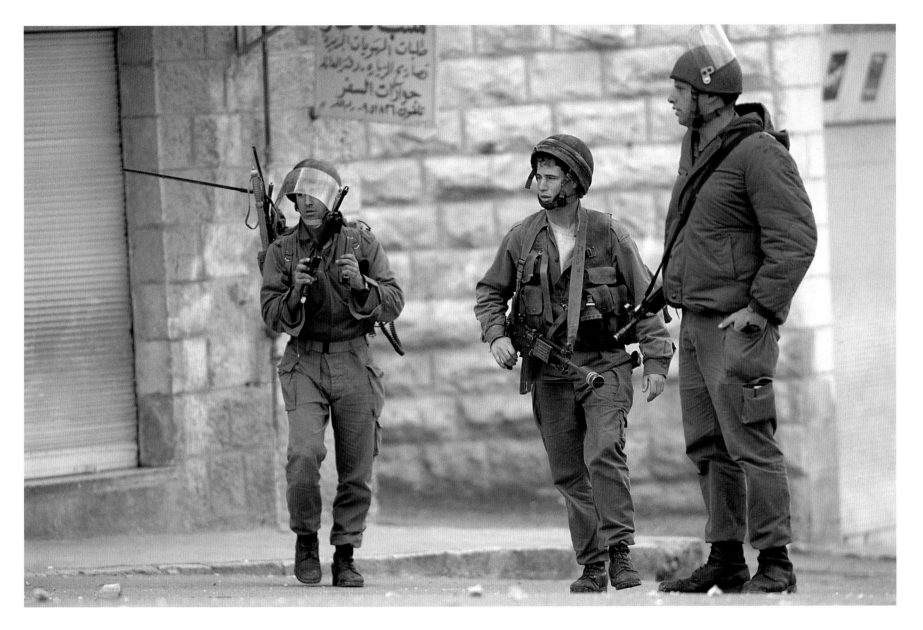

60. An Israeli trooper readies a clip of bullets before entering the town.

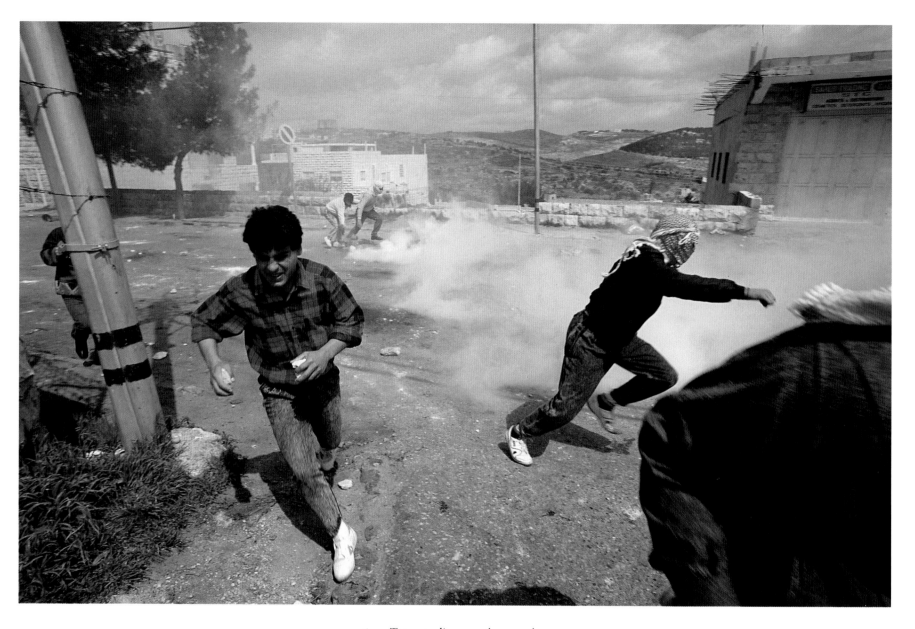

61. Tear gas disperses the crowd.

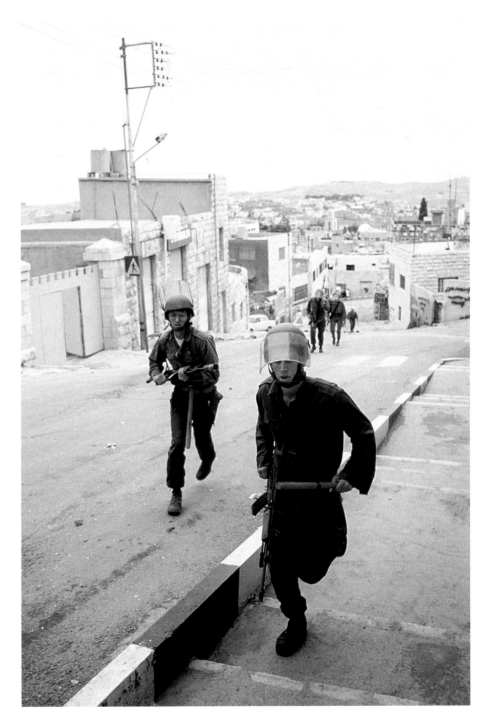

62. Israeli troopers with batons storm the town.

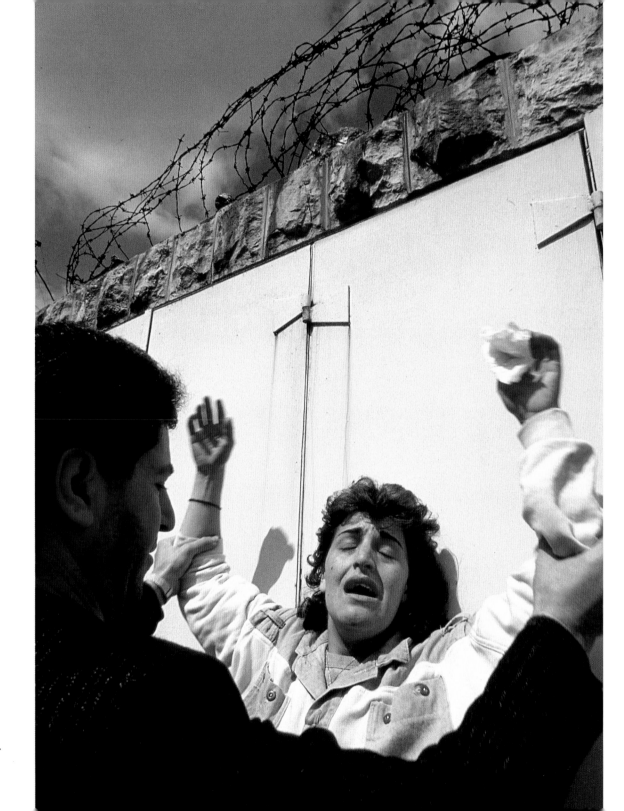

63. Reviving a woman stricken by tear gas.

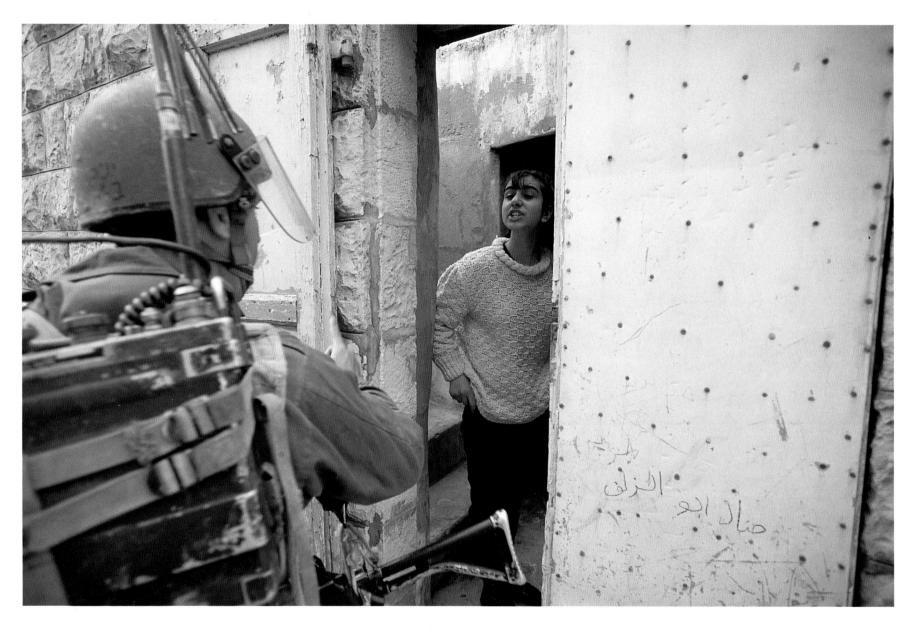

64–65. A house-to-house search.

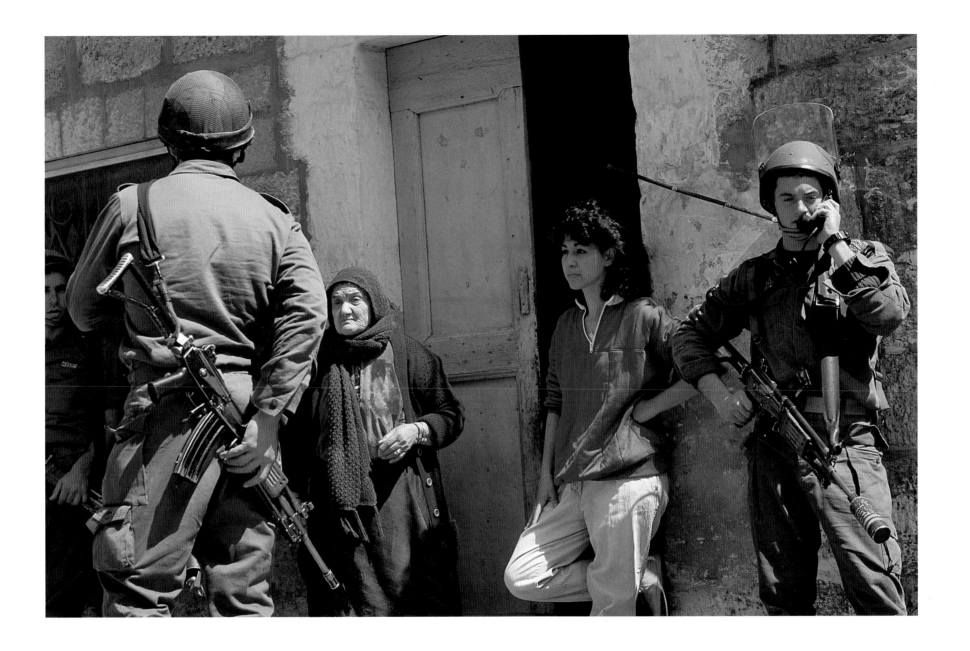

To all people of conscience everywhere, to democratic forces, to all defenders of human rights: We call on you to rescue us from the camp of slow death, Ansar 3, Negev.

We the thousands of Palestinian detainees have been thrown by the Israeli authorities into Ansar 3 detention center, with no regard for the simplest judicial formalities, including our right to know the charges leveled against us. We are kept in difficult circumstances under the burning desert sun, where the temperature reaches 45 degrees centigrade by day and drops to below zero at night, in an area teeming with reptiles, insects, and rats. However, the severity of nature is no match for the cruelty of the soldiers of the detention center, with their arbitrariness and constant brutality and violence.

Water is scarce and is cut off for many long hours daily. When there is water, it is hardly sufficient for drinking, toilet needs, and baths twice monthly in the suffocating heat. We have only one change of clothing, our health is deteriorating, and we are suffering general physical depression and various diseases. These conditions are accompanied by the total isolation imposed on us; our families are not allowed to visit because of the restrictions imposed by the authorities, in spite of the length of our detention. We are not allowed to send or receive letters, nor are we allowed to have radios, newspapers, magazines, books, writing paper, or pencils.

We call on you to stand by us to put a stop to organized violence and humiliation, leading us to a slow death. They are assassinating justice and the potential for peace, which all beings long for in this holy land.

[Letter, signed] Palestinian Detainees
at the Camp of Slow Death,
Ansar 3, Negev Desert. May 1988

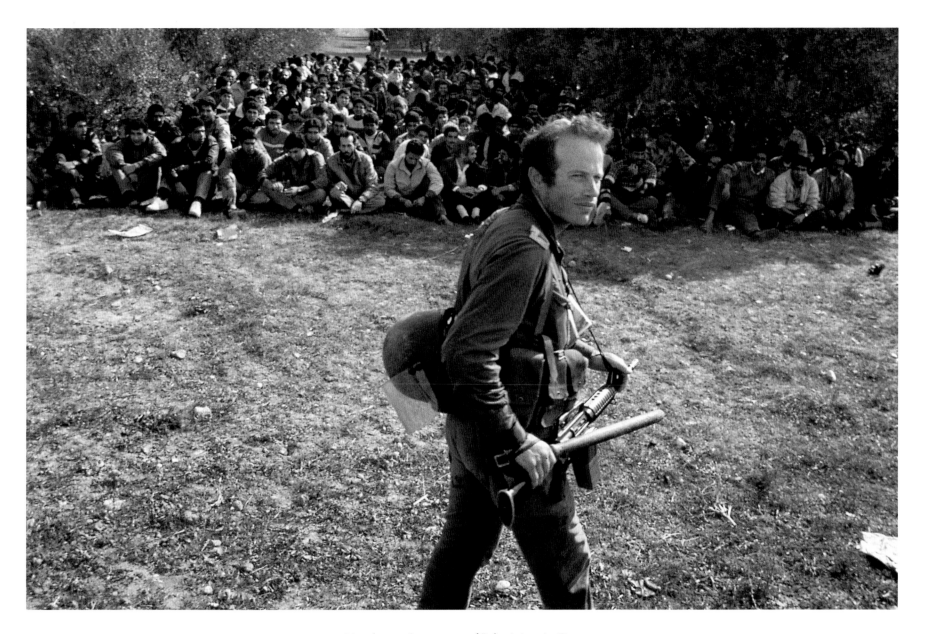

66. A mass internment of Palestinians in Gaza.

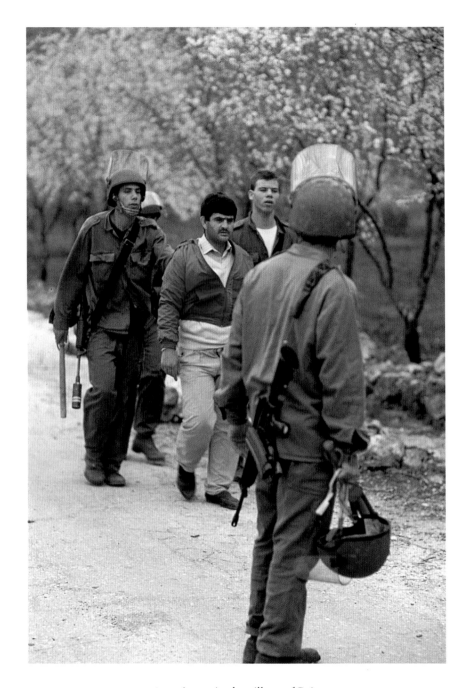

67. Arrest in the village of Beita.

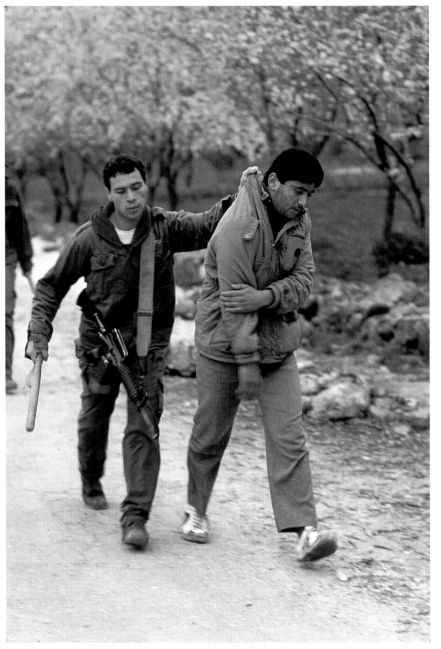

68. Fractured elbow.

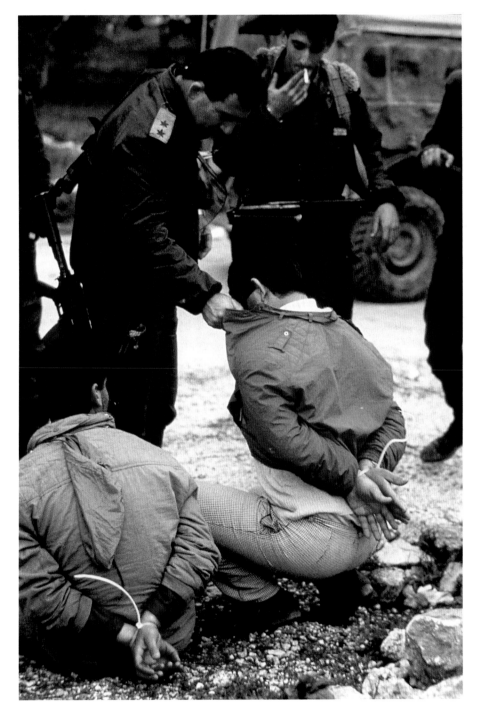

69. Preliminary interrogation.

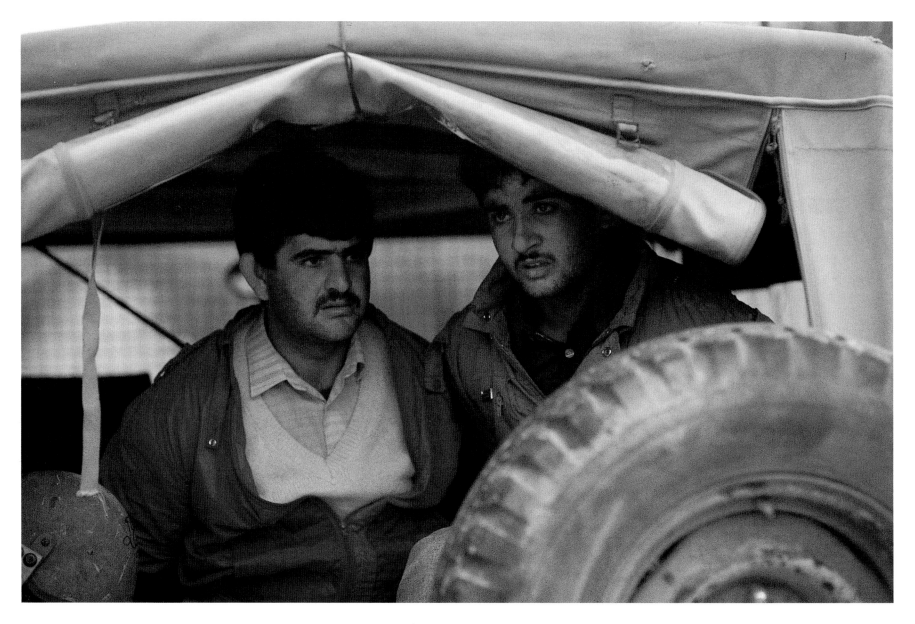

70. The trip to prison begins.

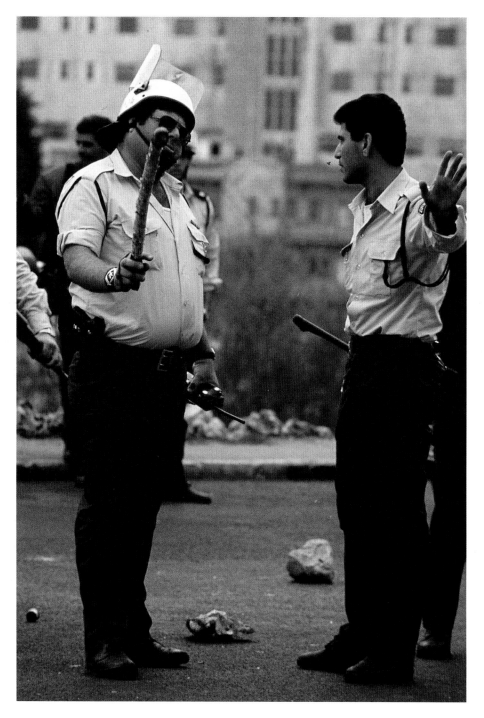

71. Israeli policeman with a baton carved to resemble a penis.

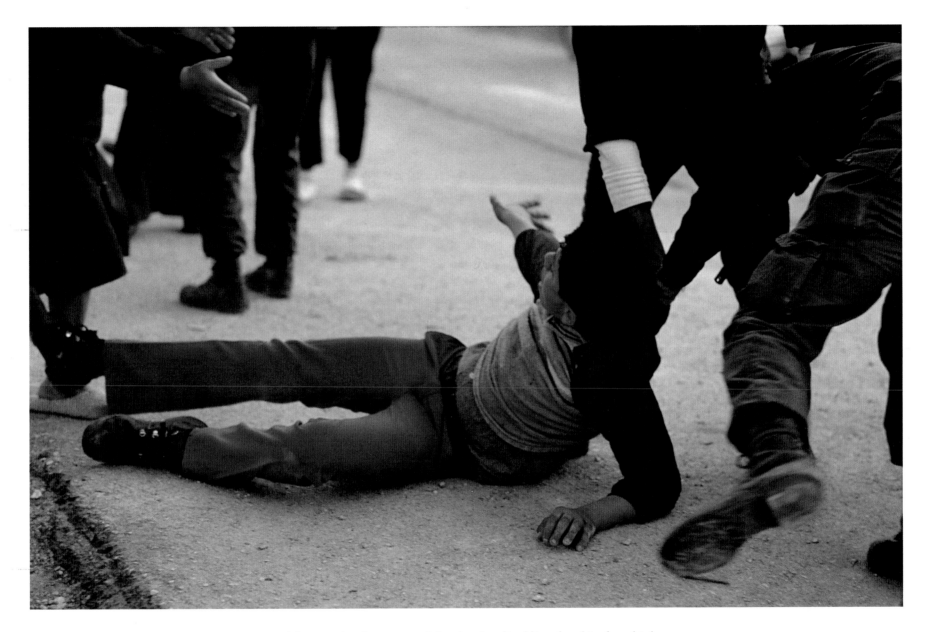

72. A boy reaches for a woman's hand as Israeli soldiers drag him from his home.

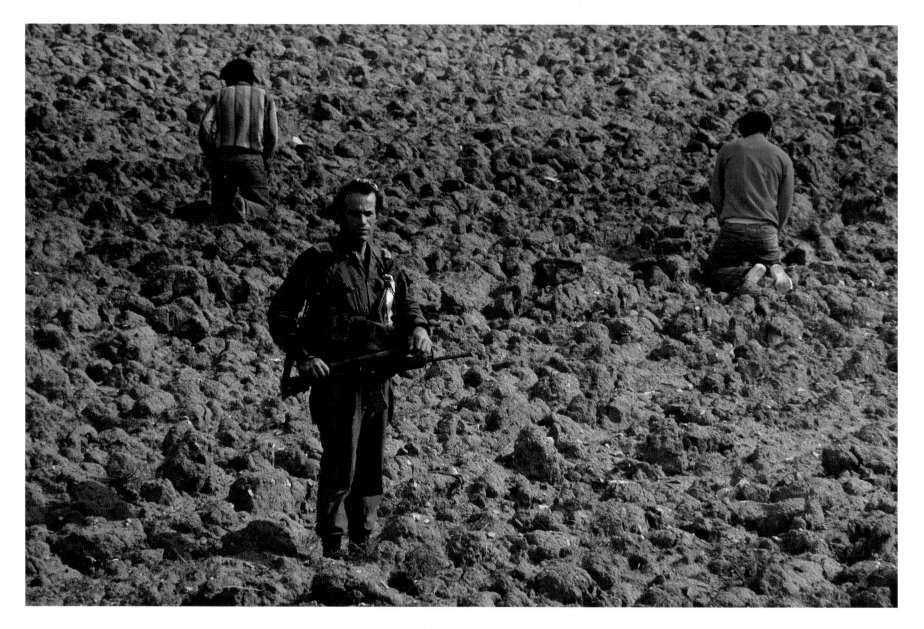

73. Prisoners in a field near Gaza City kneel to urinate.

I sit in preventive detention
The reason, sir, is that I am an Arab.
An Arab who has refused to sell his soul
Who has always striven, sir, for freedom.
An Arab who has protested the suffering
 of his people
Who has spoken out against death
 in every corner
Who has called for—and has lived—
 a fraternal life.
That is why I sit in preventive detention
Because I carried on the struggle
And because I am an Arab.

Fouzi al-Asmar,
"Because I Am an Arab"

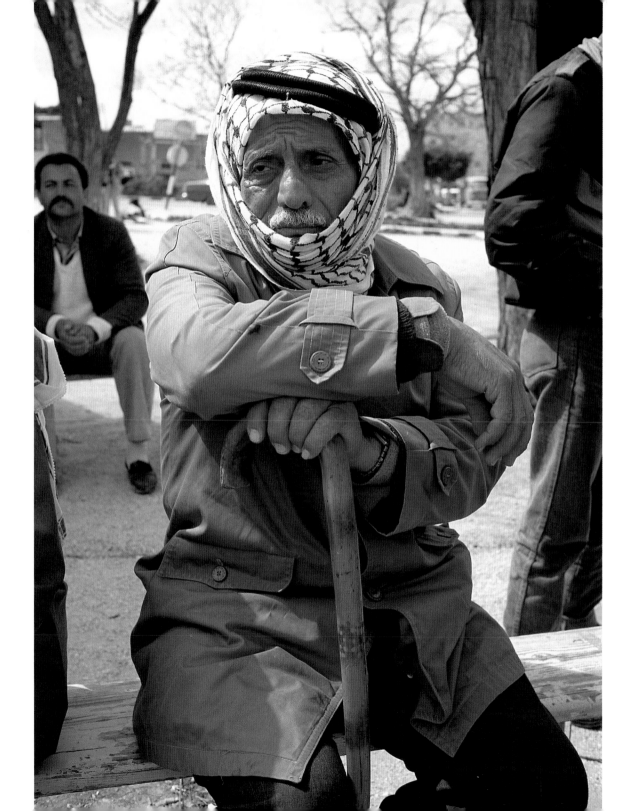

74. At the Israeli military prison in Nablus a man
 waits to see his imprisoned son, a physician from
 Balata refugee camp.

We were at a neighbor's house when we heard
shooting. People said someone was injured, so I
rushed to see what had happened.

I found Abui ["father"] on our doorstep. I saw
him gasping for air. I wanted to go with him to the
hospital. He had a bullet in his chest.

I was in a state of shock, as though I wasn't
conscious. I couldn't think . . . Then I fainted.

Linda Hamidah

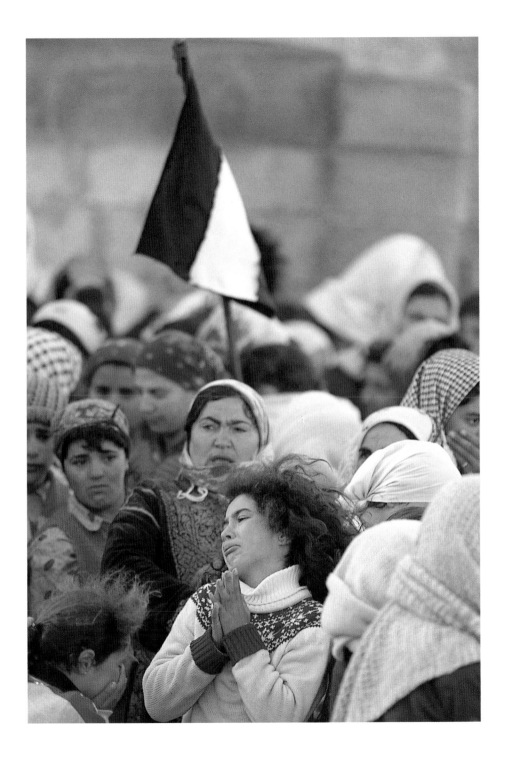

75. Linda Hamidah at her father's funeral.

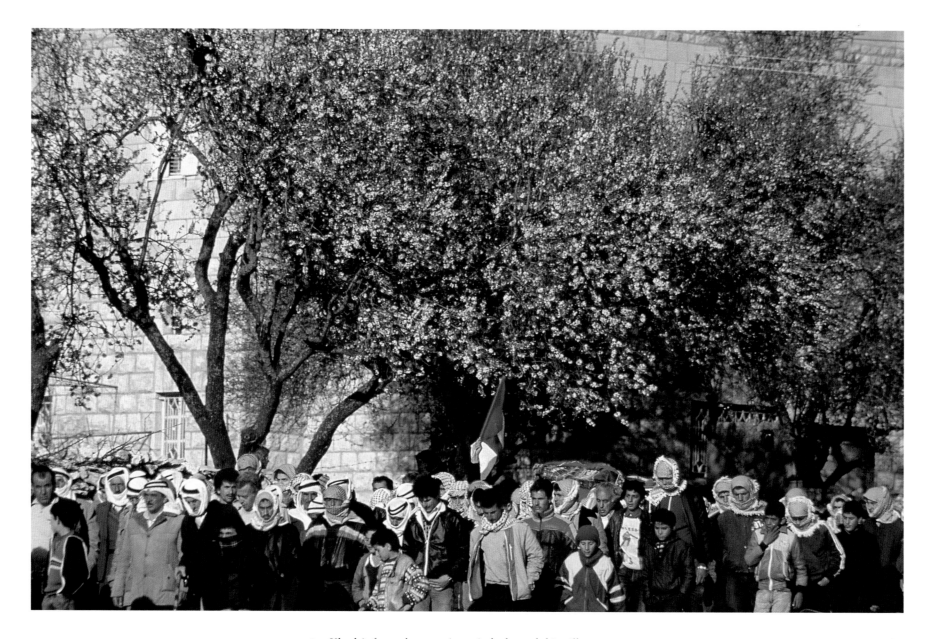

76. Khadr's funeral procession winds through his village.

This is the wedding without an end,
In a boundless courtyard,
On an endless night.
This is the Palestinian wedding:
Never will lover reach lover
Except as martyr or fugitive.

Mahmoud Darwish,
"Blessed Be That Which Has Not Come"

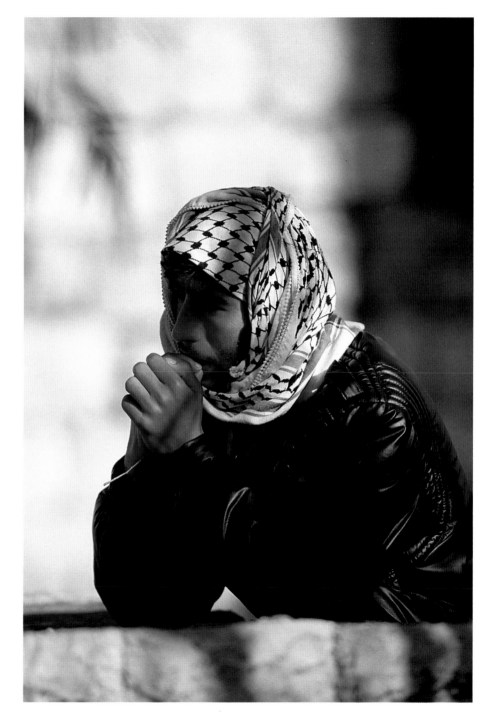

77. Prayer.

And they searched his chest
 But they could find only his heart
 And they searched his heart
 But could find only his people.

 Mahmoud Darwish,
 "Earth Poem"

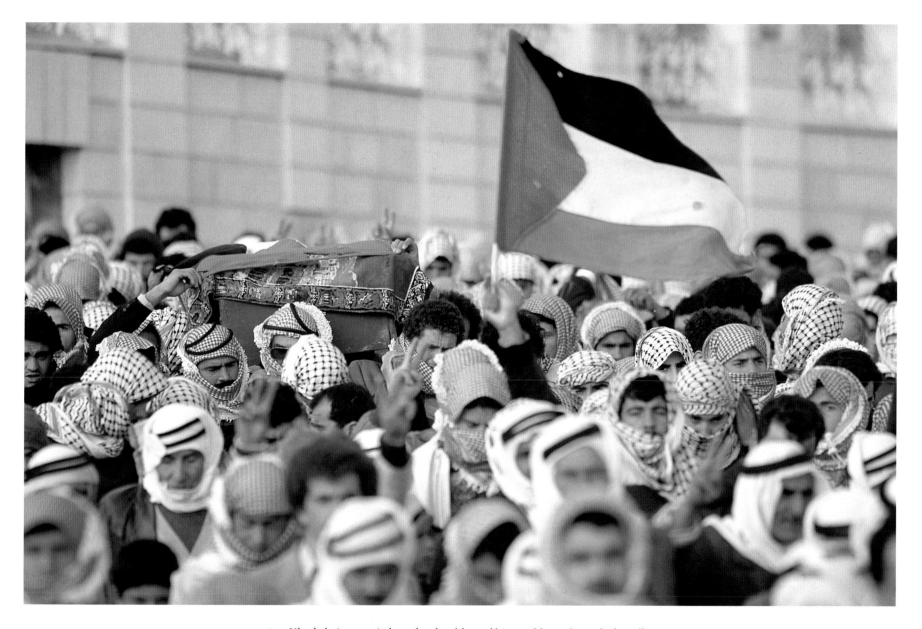

78. Khadr being carried on the shoulders of his neighbors through the village.

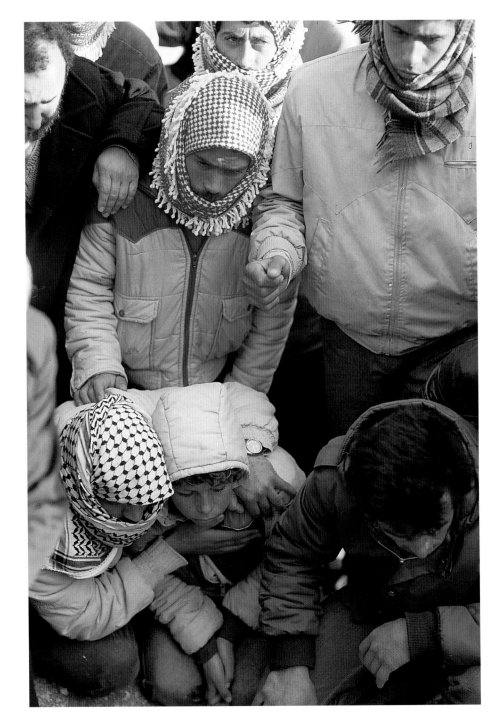

79–80. Khadr's son Muhammad, in white hooded jacket, looks on as Khadr is lowered into the ground.

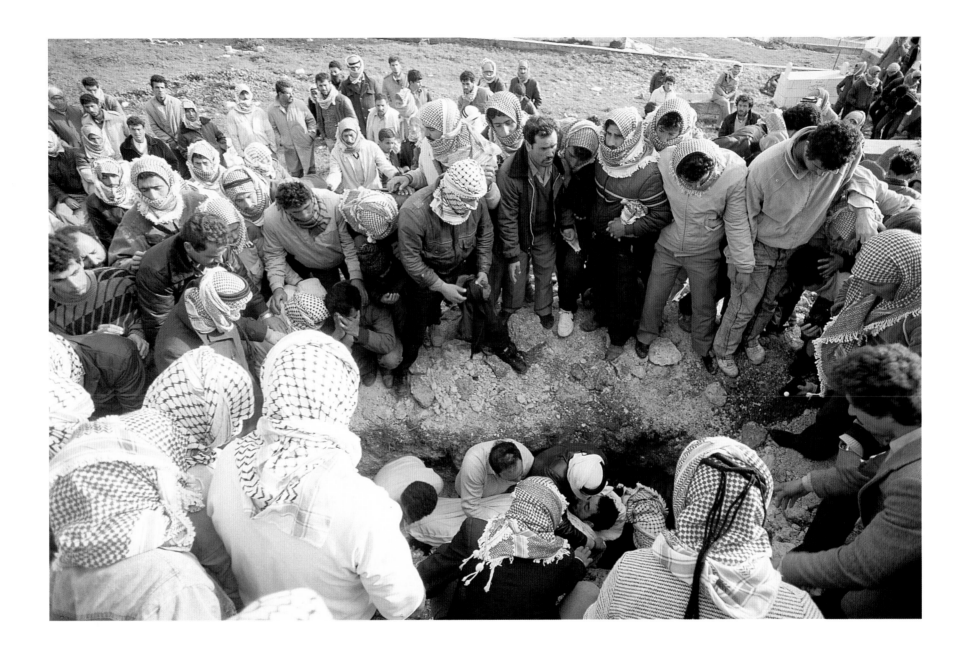

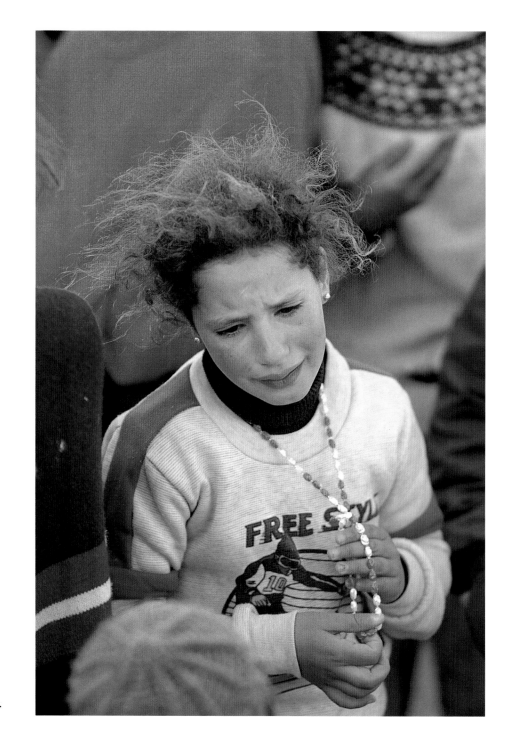

81. Grief.

82. Mourning.

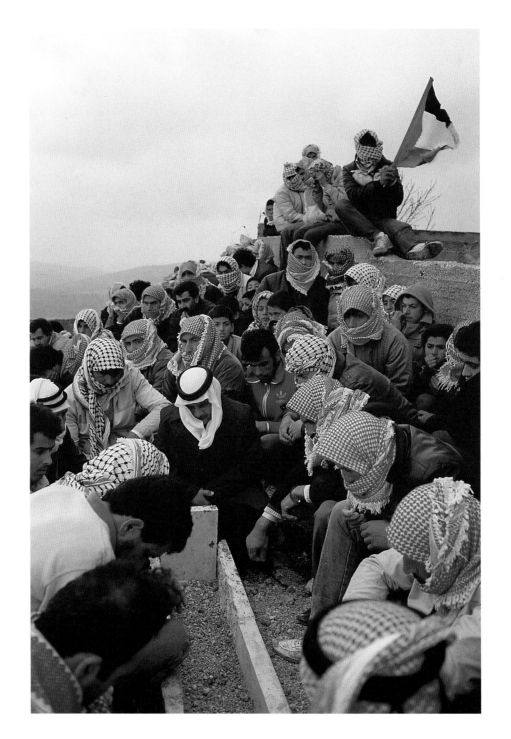

83. Town prayer.

84. *Masbaha,* "fingering beads."

The army has nearly doubled its forces in the West
Bank and tripled them in the Gaza Strip, according
to Chief of Staff Ravaluf Dan Shomron. In Gaza
alone, he told defense reporters earlier this week,
the I.D.F. has more troops deployed than it used to
occupy all of the territories in 1967.

Jerusalem Post, January 1, 1988.

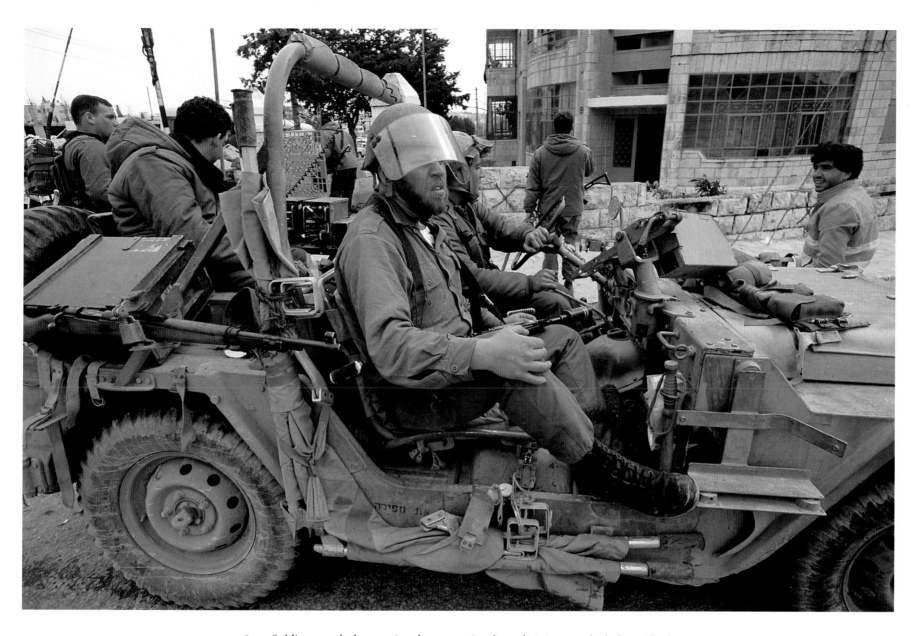

85. Soldiers watch the growing demonstration from their jeep, parked alongside the
main road outside the camp.

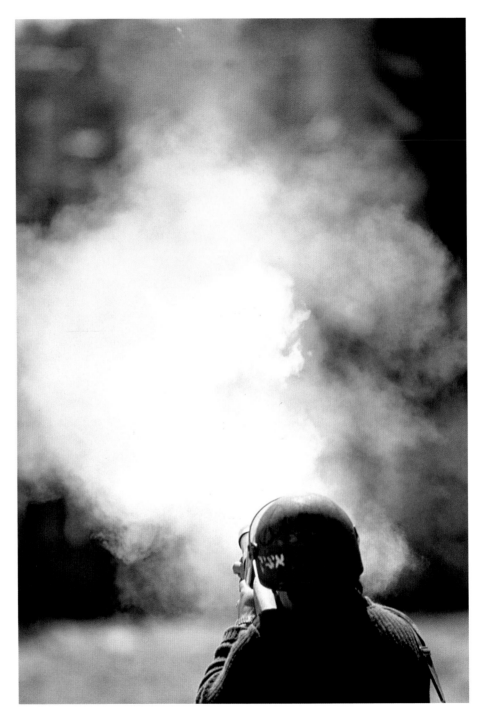

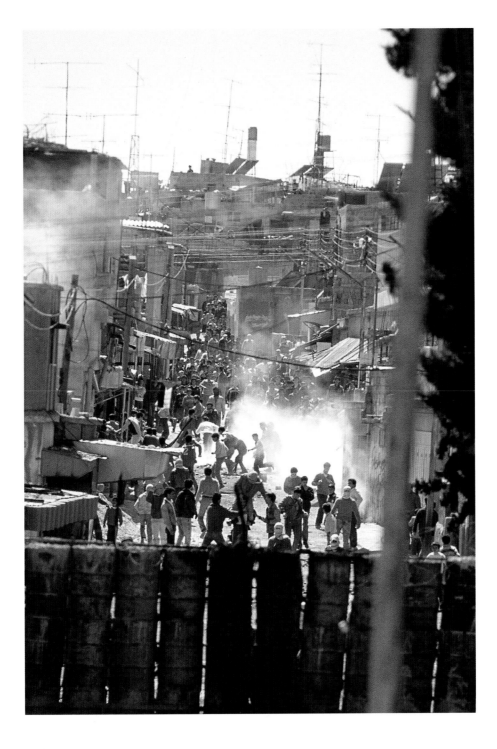

87. Tear gas engulfs the crowd, which disperses into the camp's myriad side streets and alleys.

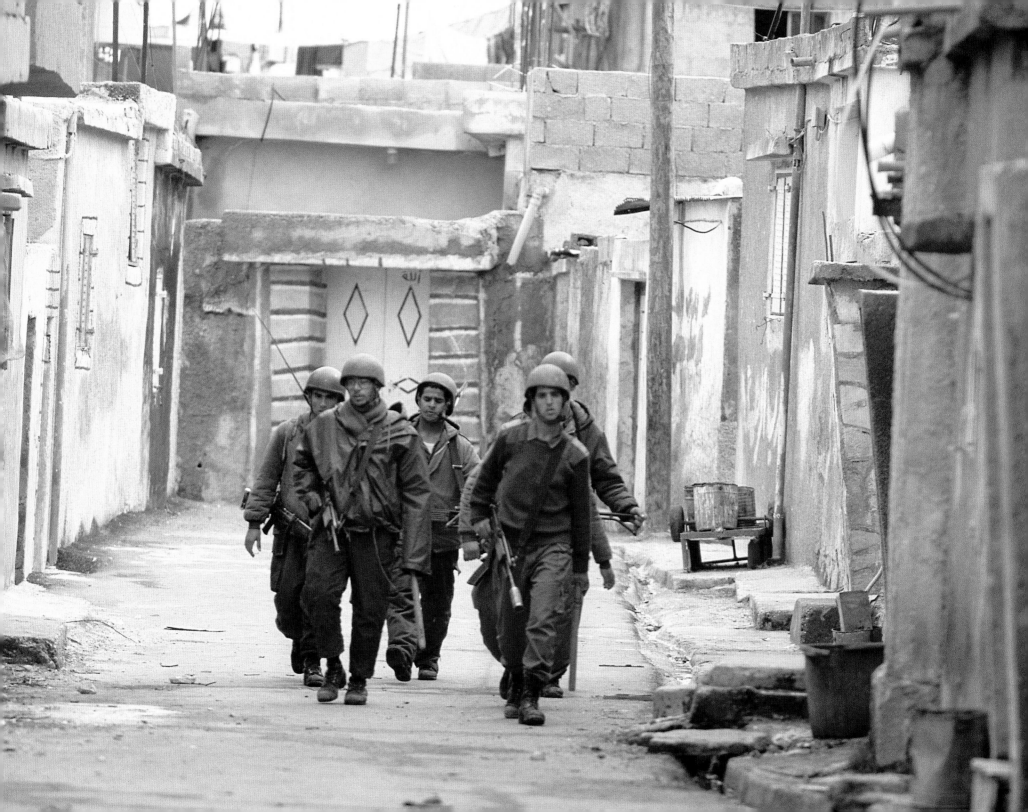

88. Squads of Israeli soldiers search the camp for Palestinian males.

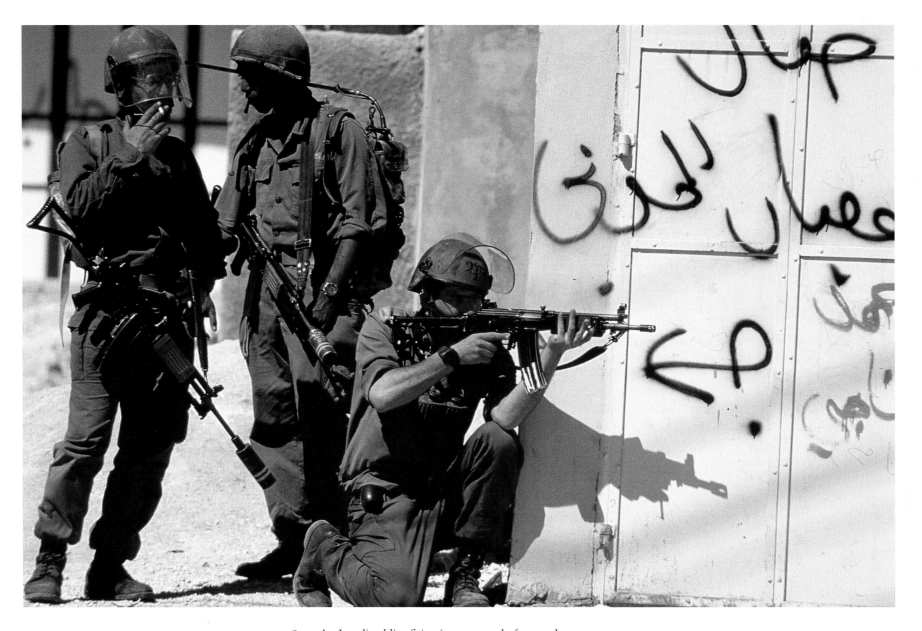

89. An Israeli soldier firing into a crowd of stone throwers.

90. A young lookout, peering around a corner beyond a roadblock made
of broken stones.

About twenty soldiers rushed into our house after breaking down the iron door. Upon seeing me and without asking any questions, they set about me with clubs and with the butts and barrels of their rifles. They threw five empty bottles at me, at all parts of my body . . .

While they were dragging me barefoot through the streets, they found a hosepipe and began beating me all over with it. The blood flowed from my head and all parts of my body. They were also verbally abusing me in the worst possible fashion. They continued dragging me in the streets for at least two hours. Then they took me to the eastern part of the village, and there they tied my hands behind my back with metal wire and a leather belt, and tied me to an electric pole. My hands were also tied to an iron chain and they started beating me with their fists, feet, clubs and the butts of their rifles. My body was covered with blood and I was screaming in pain. It's hard to describe the state I was in.

One elderly woman came forward; a soldier struck her and she fell to the ground. She tried again, but the soldiers fired many shots on the ground around me, and they hit the old woman with a stone in her stomach, which caused her to retreat.

Then a local sheikh came to untie me; they shot at him but he kept coming forward, intent on setting me free. The soldiers fell on him with their clubs and prevented him from getting to me. I remained tied to the electricity pole for about two hours. Then the soldiers tore my clothes and one of them began writing on my back while the others started beating me on the bruises I had on my back as a result of having been dragged on the ground. After that, they left me unconscious, lying on the ground.

Testimony of Mouin Abu Bakr,
nineteen years old,
Al-Haq Affidavit no. 1161
Ya'bad, West Bank
(Al-Haq is a West Bank Human Rights organization, an affiliate of the International Commission of Jurists).

. . . at about 4 P.M. I returned home. On my way I passed a small uncovered army vehicle in which there were two soldiers. When I had walked about 30 meters, I reached an alley in the middle of which were five soldiers. I hesitated between continuing walking, going back, or entering a house. Then I heard one of them shouting at me "Stop!" in Arabic. I stopped and saw him coming in my direction with his rifle pointed at me and his finger on the trigger. At a distance of two meters from me he shot a complete set of bullets. My face was hit and at once blood began pouring from my head, face, and eyes. Blood poured out and covered my shirt, trousers, and the ground. Straight away, this soldier took out plastic handcuffs from his pocket and tied my hands in front of me. Meanwhile, the other soldiers, including the two who were in the jeep, came and began to beat me up with their fists, clubs, and the ends of their rifles. They focused on my head, eyes, and ears. I started screaming while trying to cover my eyes with my hands to protect them. They continued beating me until I fell to the ground unconscious. When I regained consciousness . . . I heard the voices of my brothers and friends who told me I had been lying in Rafidiya hospital in Nablus for the past forty-eight hours. After two days the bandages were taken off my face, and I discovered that I had lost my right eye.

Testimony of Alam Abu Hattab,
twenty-three years old,
Al-Haq Affidavit no. 1245,
Jenin refugee camp.

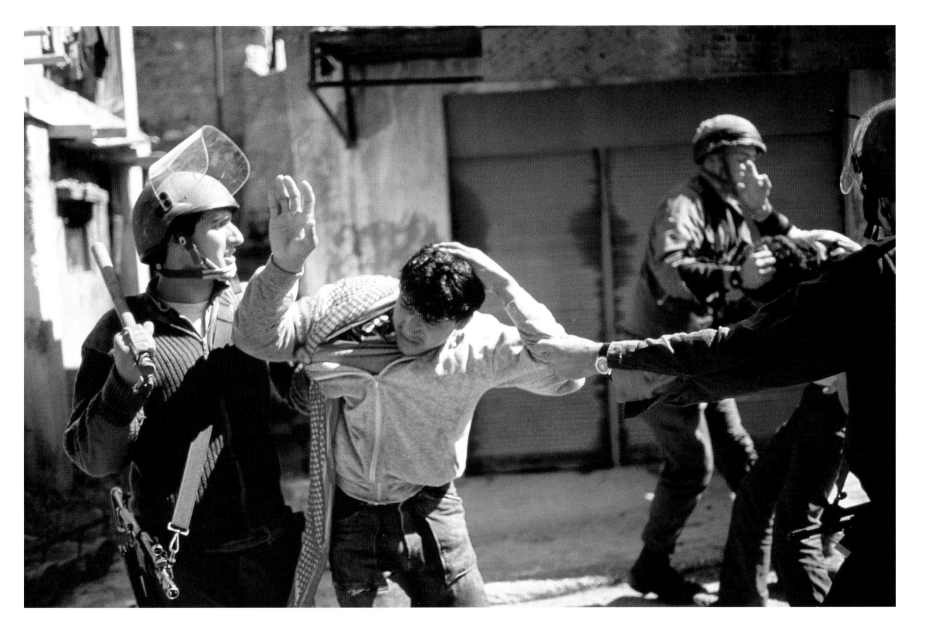

91. After breaking into a house, soldiers beat and drag away a young man.

92–93. Women attempting to free the prisoner.

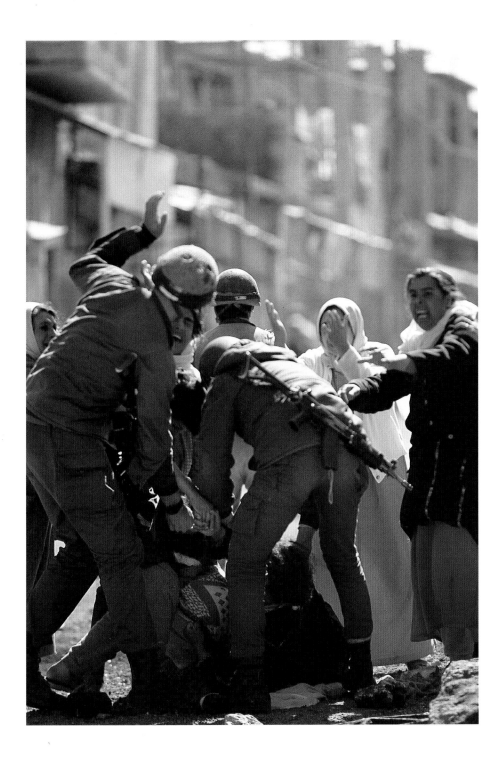

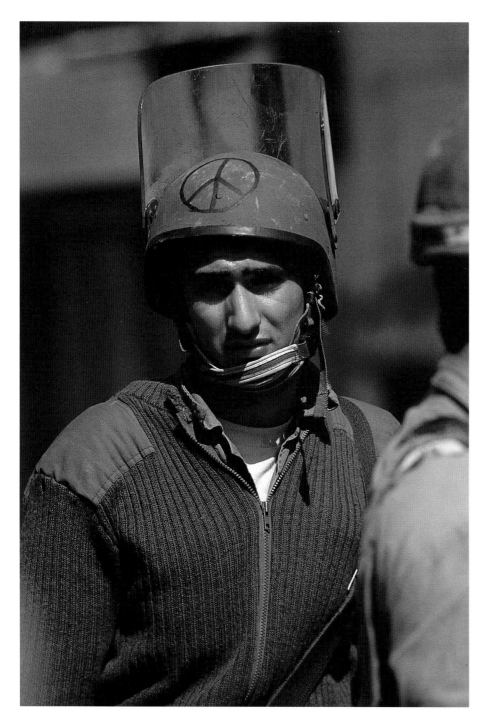

94. Portrait of an Israeli soldier.

The first priority is to prevent violence in whatever form it takes, and by force, not fire. The first priority of the security forces is to prevent violent demonstrations with force, power and blows. . . . We will make it clear who is running the territories.

Defense Minister Yitzhak Rabin,
Jerusalem Post, January 20, 1988.

95. Portrait of a camp mother.

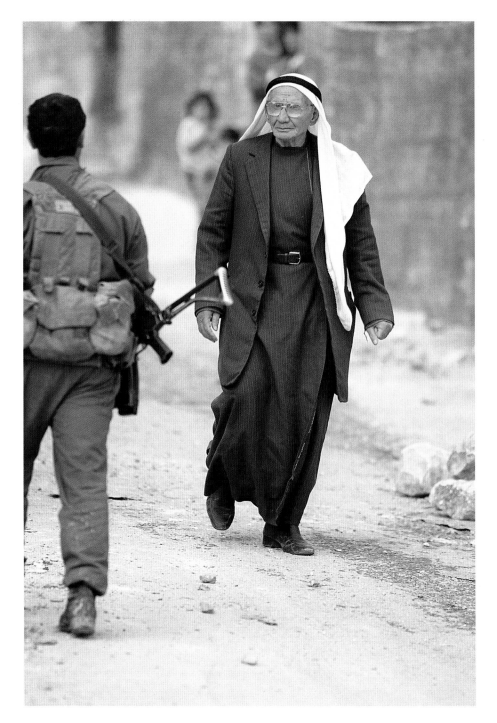

96. The occupation.

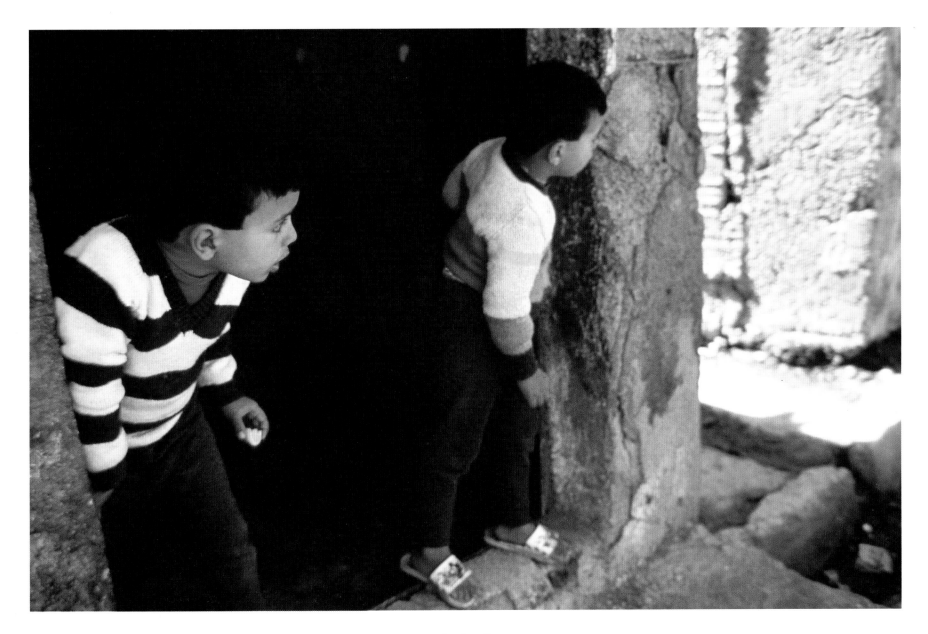

97. In the alleyway.

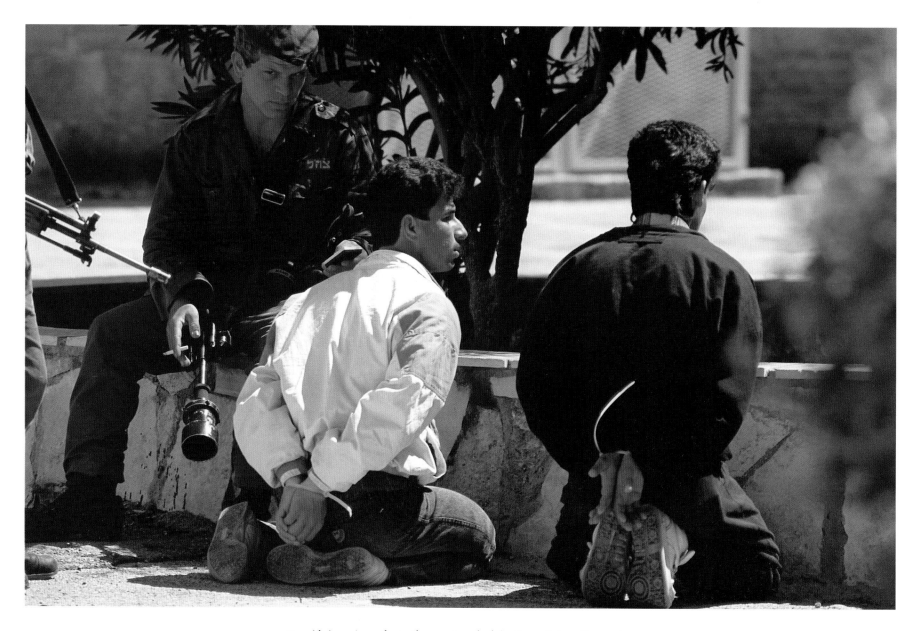

98. Al-Amari youths in the courtyard of the Ramallah police station.

I'm the one into whose skin
 the chains are digging
 an outline of the homeland.

 Mahmoud Darwish, "Birds Die in Galilee"

Hamza

Like others in my hometown
the salt of the earth
who toil with their hands for their bread
Hamza was
a simple man
When we met that day
this land had been a harvest of flames
in a windless hush it had sunk
in a cloak of barren grief. I had been
swept by the daze of defeat.
Hamza said,
"This land, my sister, has a fertile heart
it throbs, doesn't wither, endures
for the secret of hills and wombs
is one
this earth that sprouts with spikes and palms
is the same that gives birth to a warrior.
This land, my sister, is a woman,"
he said.

Days passed I did not see
Hamza
however, I could feel
that the belly of the land was heaving
in travail.

Hamza
was sixty-five
a burden deaf like a rock
saddled on his back.
"Demolish his house"
a command was ordained
"and tie his son in a cell"
the military ruler of our town later explained
the need for law and order
in the name of love and peace.

Armed soldiers rounded the courtyard of his home
a serpent coiled in full circle
the banging at the door reverberated
the order "evacuate"
and generous they were with time
"in an hour or so."

Hamza opened the window
looking the sun in the eye
he howled,
"this house, my children
and I
shall live and die
for Palestine."
The echo of Hamza propelled a tremor
in the nerve of town
A solemn silence fell.

In an hour the house burst apart
its rooms blew up to pieces in the sky
collapsed in a pile of stones burying
past dreams and a warmth that is no more
memories of a lifetime
of labor, of tears, of some
happy day.

Yesterday I saw
Hamza
he was walking down a street in town
as ever simple as he was and assured
as ever dignified.

Fadwa Tuqan

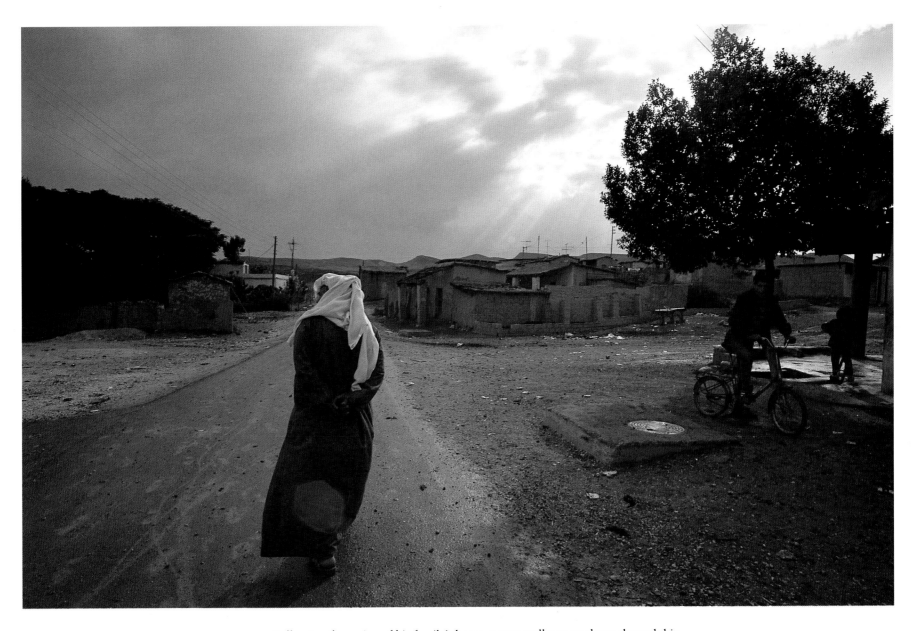

99. Following the razing of his family's home, a man walks at sundown through his
village, al-Uja, near Jericho.

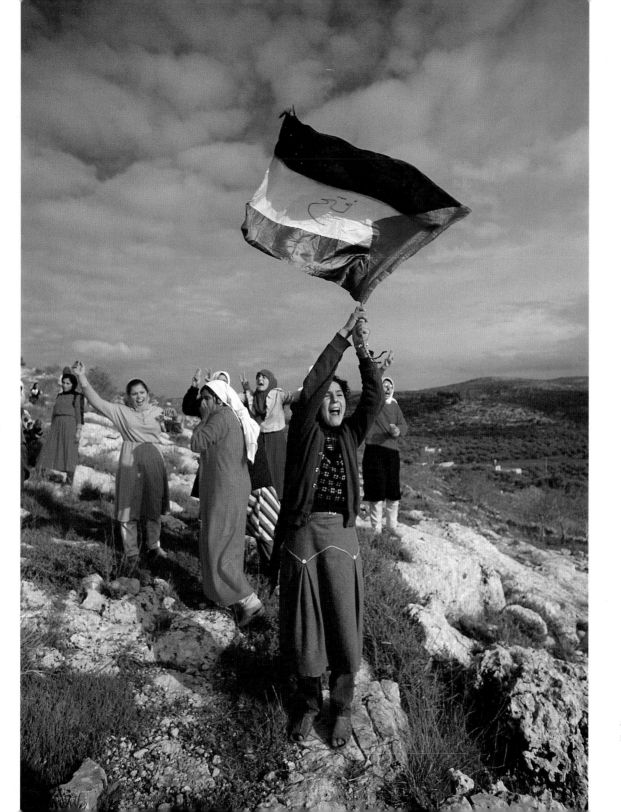

100. On a hilltop in Beita, young women wave
a Palestinian flag at a group of Israeli soldiers
menacing them with tear gas from below.